We thought you
this after your trip to
Museum.

Much love,
Steve & Lorraine

IMAGES
of America
LOGGING AND
LUMBERING IN MAINE

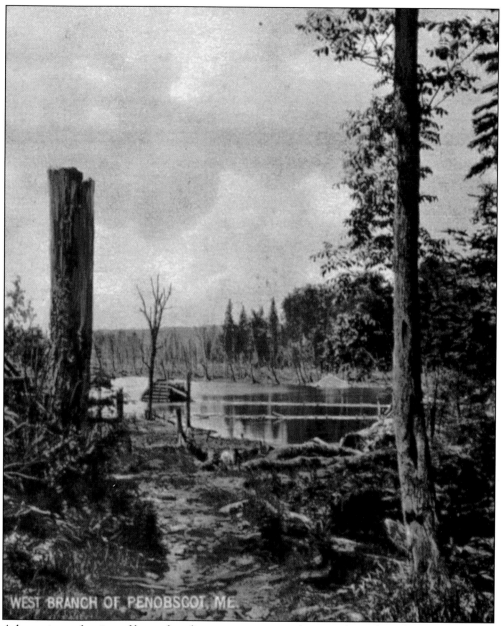

A lone pier and string of boom logs lie as a testament to bygone days when the river was alive with men moving tall timber to market. Those were the days when Maine led the world in timber production, and Bangor was known as the lumber capital of the world.

On the cover: This photograph shows woods crew in Aroostook County, probably near Haynesville or Houlton. The card is labeled "E. Bryson's Crew, 1909."

IMAGES *of America*

LOGGING AND LUMBERING IN MAINE

Donald A. Wilson

ARCADIA
PUBLISHING

Copyright © 2001 by Donald A. Wilson
ISBN 978-0-7385-0521-3

Published by Arcadia Publishing
Charleston, South Carolina

Printed in the United States of America

Library of Congress Catalog Card Number: 2001088739

For all general information contact Arcadia Publishing at:
Telephone 843-853-2070
Fax 843-853-0044
E-mail sales@arcadiapublishing.com
For customer service and orders:
Toll-Free 1-888-313-2665

Visit us on the Internet at www.arcadiapublishing.com

This work is dedicated to those who have kept Maine's logging and lumbering history and tradition alive for all of us to appreciate. They include, but certainly are not limited to, the University of Maine School of Forestry, Wildlife, and Fisheries and its faculty, past and present, and talented authors, such as Philip T. Coolidge, Stewart Holbrook, Robert Pike, Richard Wood, Alfred Geer Hempstead, Daniel Smith, and Edward "Sandy" Ives. Without them, most of us would still be trying to figure out what happened in Maine during the past century and a half. One past faculty member who was a dear friend of the author, Edwin Giddings, deserves special recognition, for his dream became a reality at Blackman Stream.

CONTENTS

Acknowledgments		6
Introduction		7
1.	In the Woods	9
2.	On the Water: The Drive	27
3.	The Kennebec Drive	53
4.	The Penobscot Drive	75
5.	At the Mills	117

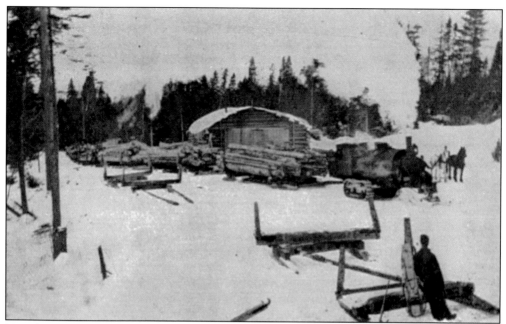
Most logging was done during the winter months. Here, a log train arrives at the yard.

Acknowledgments

Appreciation is extended to the Bangor & Aroostook Railroad Company for granting permission to use selected items from their publication *In the Maine Woods*. Their preservation of Maine woods scenery and events is unequaled.

I also wish to thank Steve Rainsford, who unselfishly shared part of his extensive collection of Maine woods photography and postal cards. His contributions obviously enhanced the book tremendously.

INTRODUCTION

Lumbering in Maine began with the first settlement. A sawmill was supposedly established near York in 1637. The first big interest in Maine timber was expressed by the king of England, who wanted the great pine trees for ship masts and established the "broad arrow" policy, claiming all trees suitable for masts in the name of the Crown.

There are some 1,620 lakes and ponds in Maine, each with its own river system. This provided both an asset and a liability to the lumbering industry. Lakes store a surplus of water, which tends to equalize stream flow, thus helping to drive out the logs by allowing extra time and by furnishing power for the mills over a long time period. Ponds and lakes also work as a disadvantage, since they add significant costs in the form of side booms and towing. Logs on dead water must be moved by man to the next quick water, where nature can take over.

It was pine that first attracted lumbermen to the area. Large trees, as much as 100 or more feet in height and 6 feet in diameter, were valuable not only for lumber but also for ship masts and spars. Around the middle to the end of the 19th century, spruce harvesting took over. This was about the time the timber industry was organized and in full swing, making huge deals. Demand for other timber species soon followed. Tamarack was cut for shipbuilding, cedar for shingles, fir for boxes, and hardwoods, such as beech, birch, maple, oak, and ash, for a variety of uses from lumber to firewood.

From c. 1820, when Maine became a state, until c. 1880, many lumbering associations were formed. Prior to that, lumbermen moved their own timber out of the woods, but they soon figured out that cooperatives could do it more efficiently, and boom corporations were chartered by the legislature. Boom corporations were responsible for getting the timber out of the woods and downriver to where it would either be processed or transported to market elsewhere, much of it being taken by ship to Boston.

After 1880, the papermaking industry was born. Spruce and fir were primarily cut and sawed into shorter lengths known as pulp logs or pulpwood, as opposed to sawlogs. This resulted in big changes in the woods in the way of mechanized logging and in the way the wood was handled. However, transportation on the waters of the state was still an efficient means of transporting wood and, therefore, continued until the mid-1970s, when it was banned.

Today, timber, whether pulpwood or sawlogs, is moved either by rail or, more likely, by truck. There is some horse logging, but very little, as most skidding is done with machinery. A vast network of roads has now replaced the watersheds as a means of getting the wood from the stump to the mill. This, naturally, has made the Maine woods more accessible than ever before.

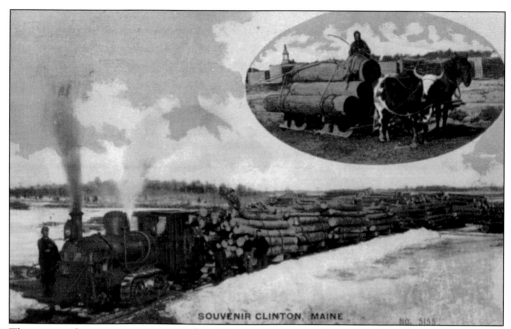
This postcard gives a comparison of early logging on a small scale and later logging on a large scale—oxen hauling a load of a few logs and a steam log hauler pulling many sleds. (Steve Rainsford collection.)

Other publications by Donald A. Wilson:

New Hampshire Fishing Maps (with Charlton J. Swasey), DeLorme, 1982.
Smelt Fly Patterns, Frank Amato, 1996.
Maine Aquatic Insects: Mayflies, Caddisflies & Stoneflies, Adventures in Angling, 1997.
Glimpses of Maine's Angling Past, Arcadia Publishing, 2000.
Maine's Hunting Past, Arcadia Publishing, 2001.

One
IN THE WOODS

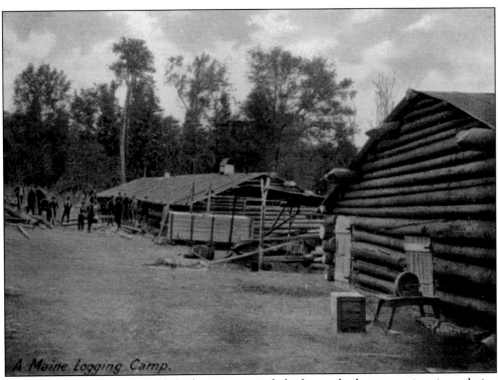

Larger logging operations established camps, most of which were built at strategic points relative to their current harvesting operations. Camps consisted of repair shops, boardinghouses, stables, offices, a blacksmith shop, potato houses, dynamite houses, and the like. Smaller cutting camps were established in outlying areas. Many of these same camps were used by the log-driving crews in the spring. This photograph shows a typical camp in either the summer or fall months. Note the equipment outside, such as the grindstone for sharpening axes in the right front.

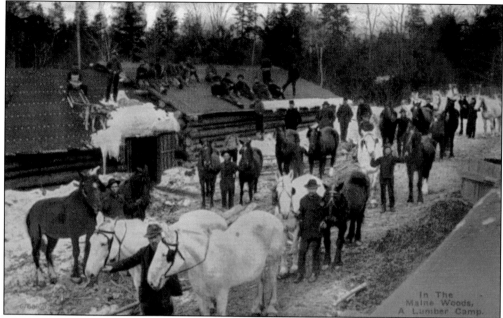

The camp crew poses for a group shot. Skidders are ready with their teams to go off for the day's work. This camp is a fairly large one, with nine pairs of horses shown here. Teamsters were often known as "hair pounders." A crew usually consisted of 6 to 9 men to a team, or about 10 to 50 men to a camp.

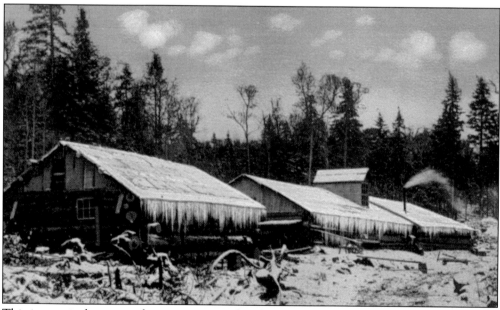

This is a typical camp in the winter, covered with snow and icicles. It was bitter cold work at best, but logs are more easily moved on snow and ice. Also, the riverbanks must be lined with logs when the spring freshets arrive; otherwise it means waiting another year to move the wood. Timing was very critical, giving rise to the expression "keep the wood moving."

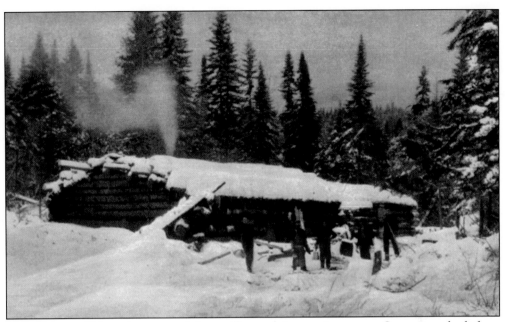

This camp would have been one of the smaller, outlying cutting camps. Camps were built from logs cut on the spot. Spaces between the logs were stuffed with moss to keep out the cold, and the roof was shingled with splits of cedar or spruce.

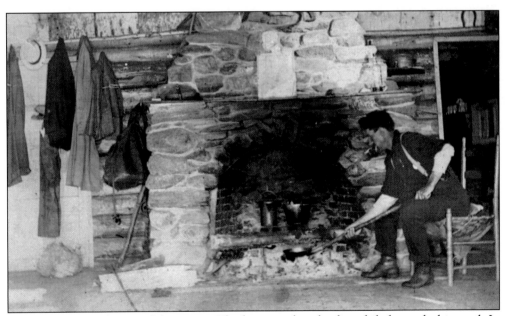

Here is a shot inside one of the camps. The logger stokes the fire while he cooks his meal. In the meantime, his clothes hang on the wall near the heat, probably drying out.

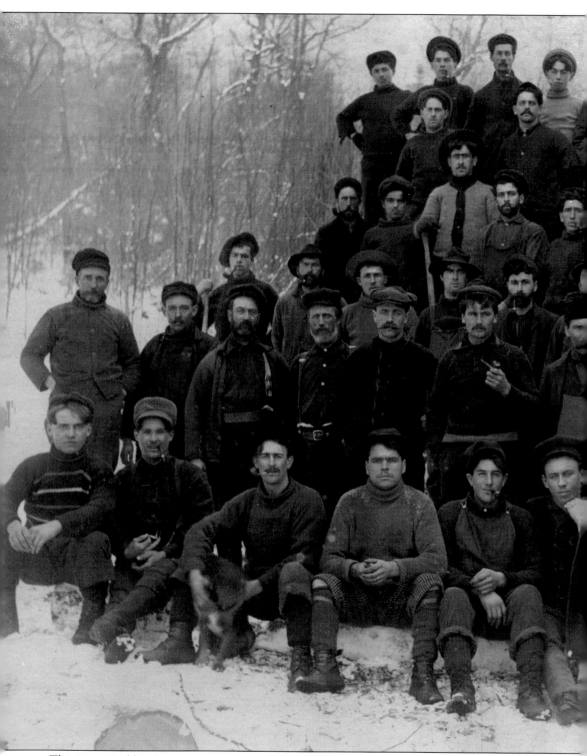
This is a typical logging crew pose. Generally one person is holding a rifle, probably a crew boss. Part of his job is to help keep the camp supplied with fresh meat. He was known as the "camp

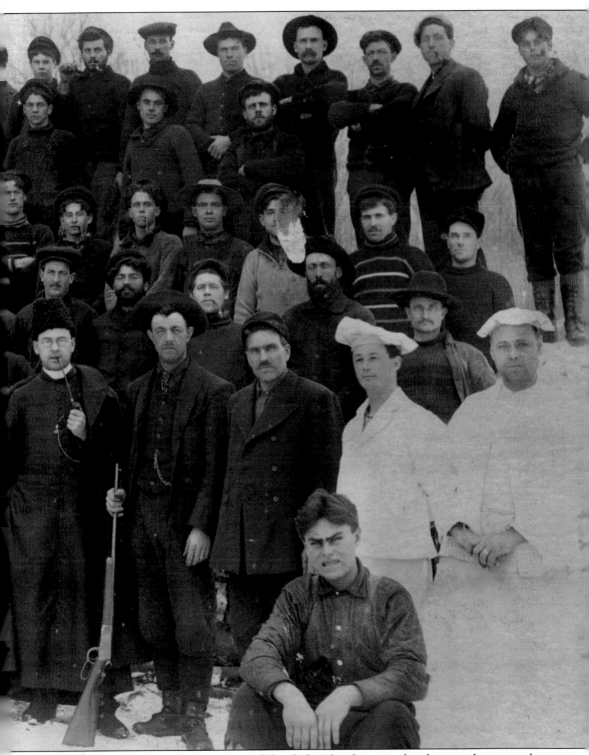

hunter." Standing next to him is a man of the cloth. Also shown in the photograph are a cook and a "cookee," or cook's helper, whose job it is to keep the crew well fed.

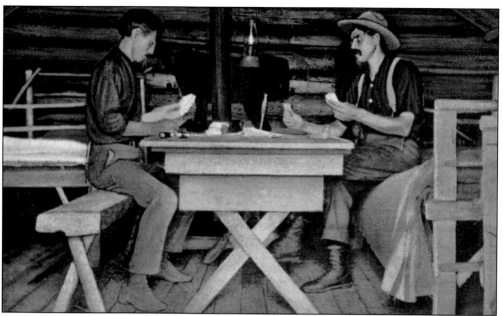

Card games, such as cribbage, seven-up, rummy, and forty-five, occupied workers during evening hours or time off from work. (Steve Rainsford collection.)

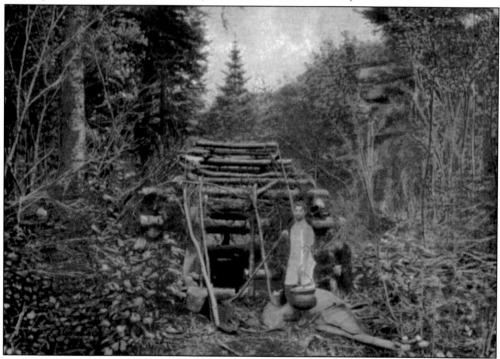

Food generally consisted of beans, biscuits, pork, salt cod, johnnycake, molasses, and tea "strong enough to float a horseshoe and hot enough to melt one." The bean hole, a hole in the ground in which beans were baked, was used as an oven. Hardwood coals were raked into it and onto the top of the bean kettle, which had a tight lid, and then it was covered with dirt. Bread could be baked in a similar manner. (Steve Rainsford collection.)

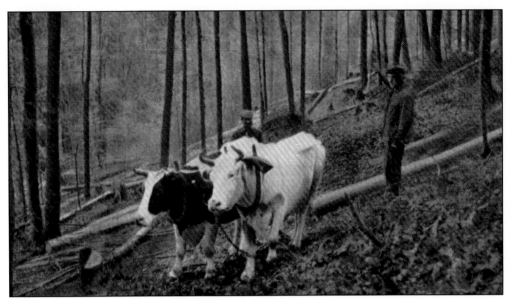

Here, a crew skids logs with a team of oxen, called "bulls." The driver was known as a "bull whacker." An ox was the favorite draft animal in the Maine woods during the first part of the 19th century. Horses were not used in any great numbers until later.

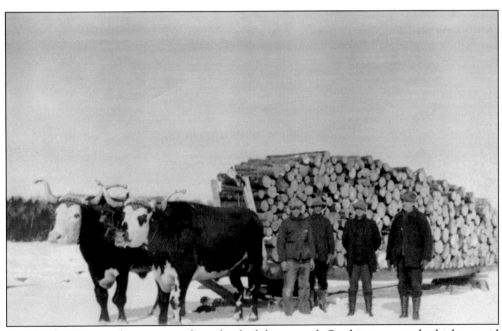

A pair of oxen is ready to move a large load of short wood. Ox drivers were the highest paid crew members, since oxen demanded more care and could haul larger loads than horses.

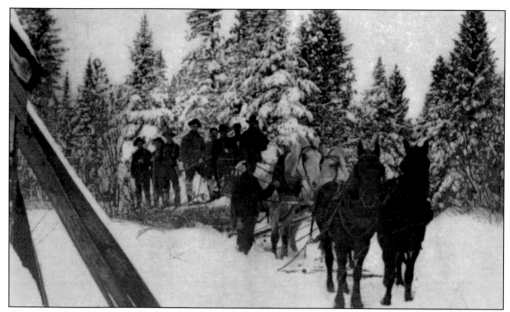

Crew members hitch a ride behind a team to where they will cut, fell, and limb logs while the team hauls the logs to the yard. A teamster using four horses teamed up for skidding or hauling was known as a "four-up skinner." (Steve Rainsford collection.)

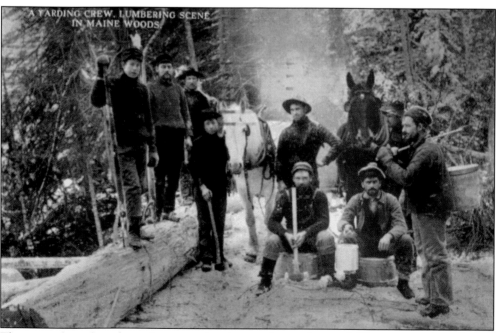

The crew takes a breather prior to moving the next log to the yard. The man on the right has brought food and hot drinks from camp for the workers. (Steve Rainsford collection.)

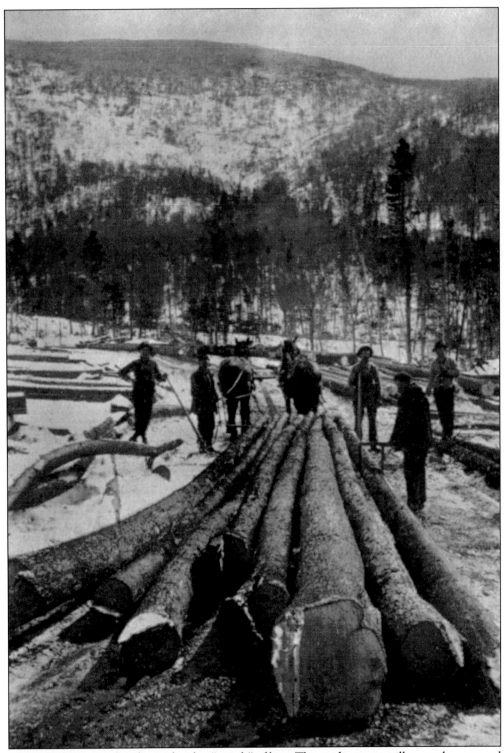

This team has arrived at the yard with a "twitch" of logs. The yarding crew will now take over and "deck" the logs in stacked piles. The mountain in the background has been pretty well cut over.

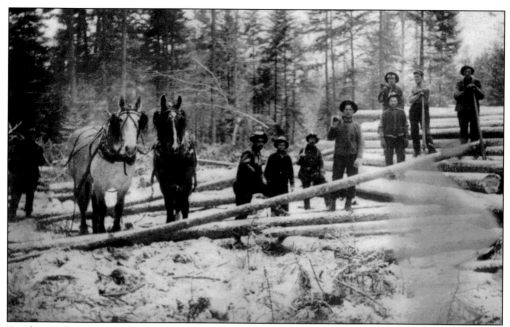

At the yard, some unhitch the horses while the yarding crew piles the logs using peaveys, or cant dogs.

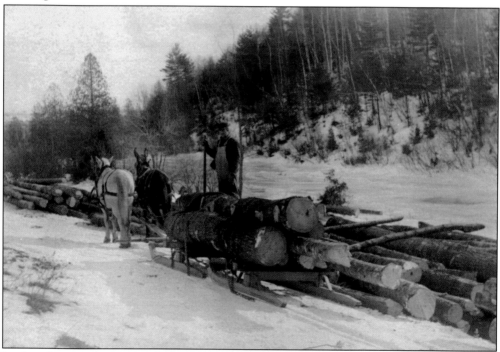

In this photograph, logs are being moved using sled runners called drays. Cross-timbers laid on top of the decked logs served as a ramp. This way, one man could load a sled by himself. The chains wrapped around the load to hold it in place were known as "belly wrappers," and there were a number of hitches favored, known as "binds," depending on conditions, just like a variety of knots for ropes.

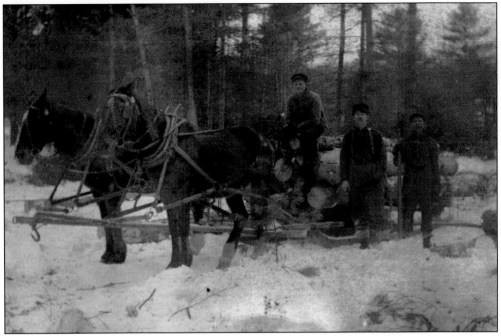

Using a sled, a small crew can move a sizable load on snow with a pair of horses, as seen here. This photograph shows the type of harness arrangement used.

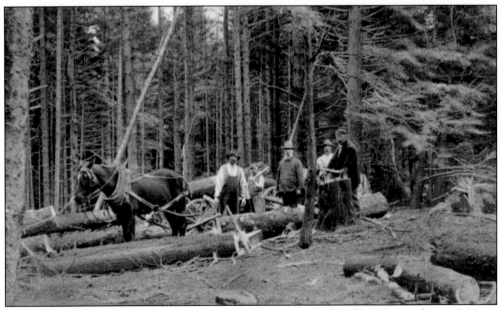

Felled timber is being made ready to hitch to the horse, which will skid it to the yard. Here, one horse pulls a wheeled wagon.

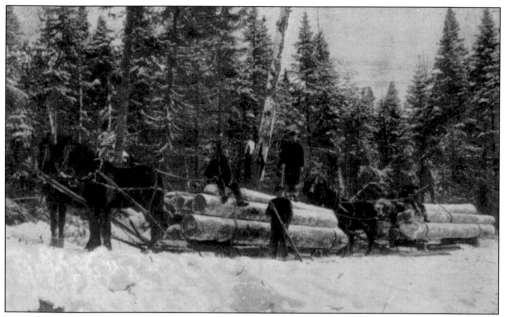
Large loads can be moved on runners with one or more teams of horses.

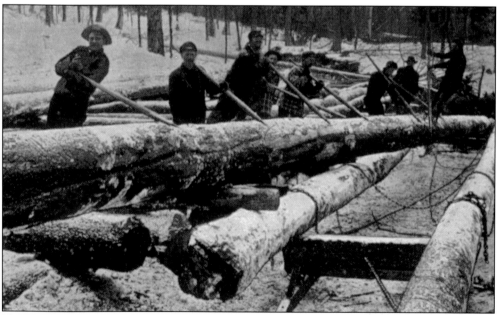
Using only peaveys, a team of eight men is moving a long log onto a sled. The peavey is a tool invented in 1858 by blacksmith Joe Peavey of Stillwater. He lived on the Penobscot River and, after watching logging crews work with crude tools, went to his shop and fashioned a tool that not only is popular and useful today but also revolutionized work in the woods and on the water.

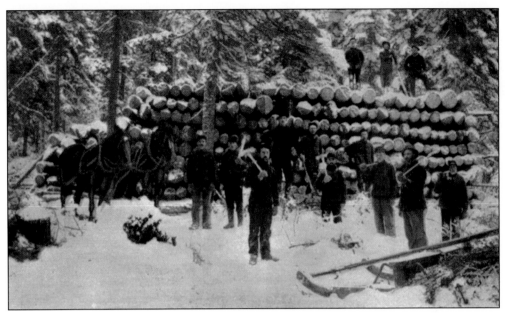
At this yard, the crew has assembled a large stack of logs.

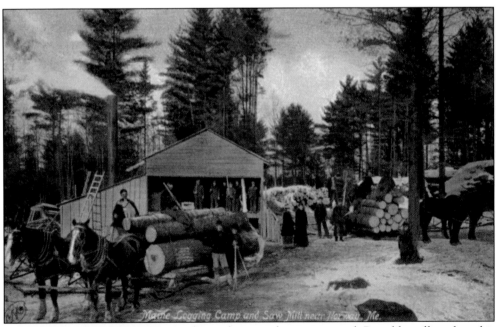
A sawmill dominates this picture, as horses bring in the raw material. Portable mills such as this were set up at strategic locations and when all available timber had been sawn and processed, the mill would be disassembled and moved to a new location.

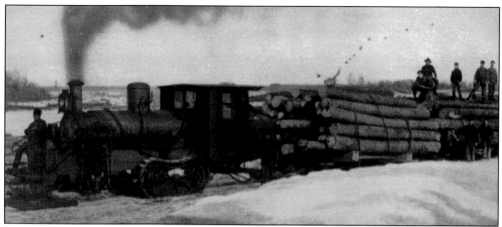

Alvin O. Lombard of Waterville was born in 1856 and patented the Lombard Steam Log Hauler in 1901. For years, lumbermen had been searching for a mechanical replacement for the four-horse team to move heavy sled-loads of logs. The Lombard machine was like an ordinary locomotive, except that lags, rather than wheels provided the traction. This worked well on snow. Early machinery had a single or a pair of horses hitched in front to do the steering. Later machines had a steering wheel added to the front. A Lombard could maintain a speed of four miles per hour and, in theory, could perform the work of nine times a four-horse team in a single day. Breakdowns were frequent, however, especially in cold weather, and in some areas mechanical operations were abandoned in favor of horses.

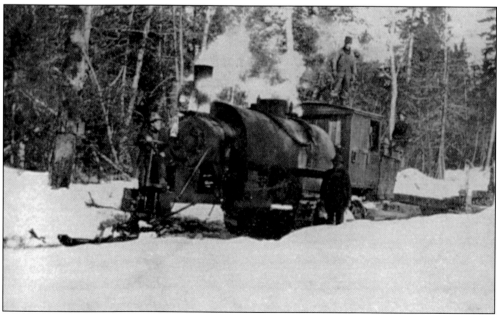

Alvin O. Lombard continued to improve his machine, and steam log haulers were used almost everywhere in the woods until c. 1930. The machine was finally driven out of business by the cheaper and more powerful Caterpillar tractor. (From In the Maine Woods, 1911.)

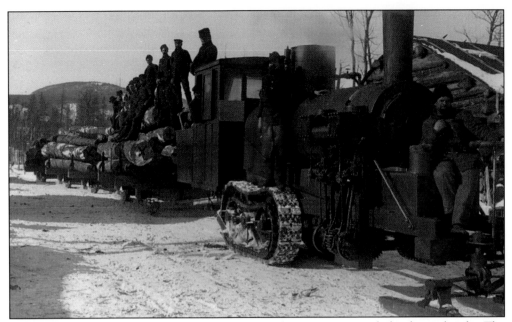

Many log haulers were equipped with headlights and were run in two shifts, day and night. The water tank had a capacity of 10 barrels, providing steam to run about 5 miles. A log hauler could haul as many as 24 sleds of long logs, making a train 1,650 feet long. Usually three sleds were the maximum. There were no brakes on these machines, so it was risky business at best under some conditions. (Steve Rainsford collection.)

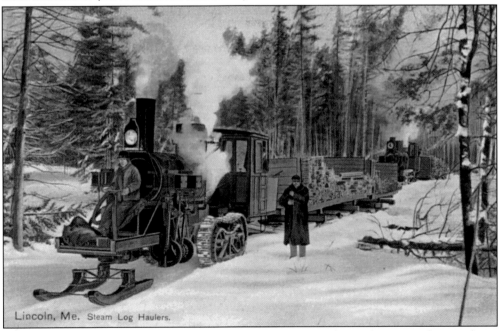

The last big operation in Maine was in 1928 on Cooper Brook, a tributary to the Penobscot River. The Great Northern Paper Company hauled more than 900 tons of coal into the woods there for their 20-ton Lombards, built one trestle 1,250 feet long, and removed 42,000 cubic yards of dirt and rock to ease the grades.

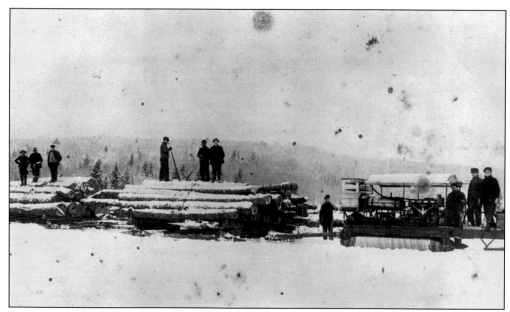

Ira Peavey built this log hauler, which was powered by a gasoline engine. It had a screw-auger tread and bored itself along on the snow surface. It seemed to work well on a lake or flowage, where the surface was smooth, but did not perform well on a woods road. The one shown here was used in the Bucks Cove area of Sebec Lake. (Steve Rainsford collection.)

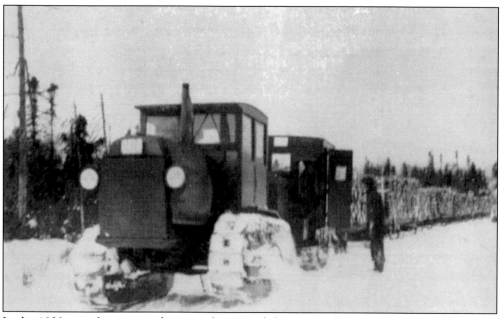

In the 1930s, gasoline-powered tractors dominated the scene. They could haul many sled-loads of wood at a time and, unlike horses, did not need to be fed and did not sleep. Equipped with lights, they could work around the clock and allowed companies to move more wood than ever before. (From the *Northern*, January 1927.)

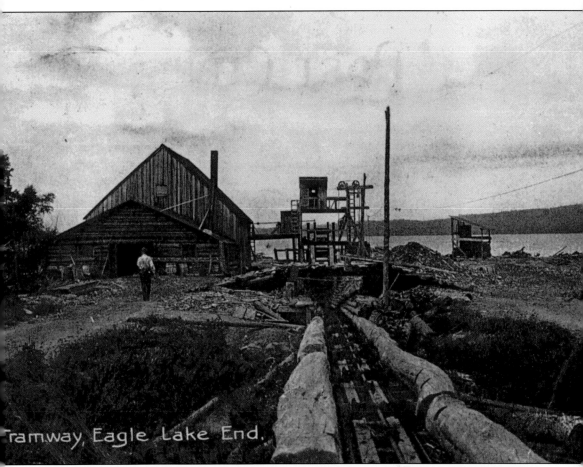

Tramway, Eagle Lake End.

This was the most ambitious transportation innovation. The idea was to move logs from the northern part of the state into the Penobscot River watershed and on to Bangor, instead of utilizing the north-flowing rivers, which eventually take logs into Canada. The machinery, consisting of two boilers weighing 8 tons each and a wire rope that was 1.5 miles long weighing 13 tons, was transported from Bangor to Greenville in 1901. It was ferried to Northeast Carry at the head of Moosehead Lake and then taken 42 miles to Eagle Lake, where it was assembled. The cable, 1.5 inches in diameter, ran about 2,000 feet with the logs and returned. Logs moved about 250 feet per minute. For six years, the tramway moved about 500,000 feet of logs every day, or about 15 million to 16 million feet a year. It was estimated that 100 million feet moved over the tramway and on to Bangor mills, which would have otherwise gone to Fredericton, New Brunswick, via the St. John River.

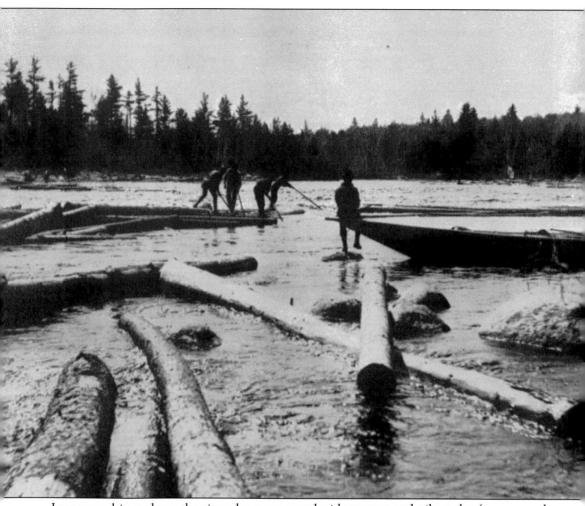
Logs were driven down the rivers by crews armed with peaveys and pike poles (pronounced "pick" poles). Rivers were navigated by means of bateaux that were well suited for high water.

Two

On the Water: The Drive

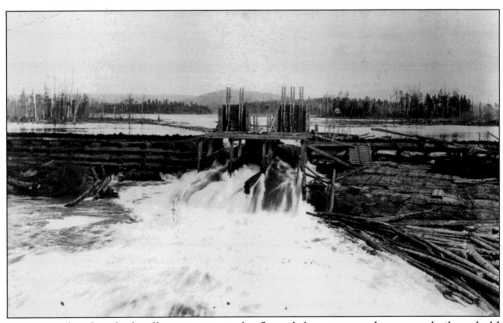

To ensure that logs had sufficient water to be floated downstream, dams were built to hold back water, which was released when the time was right. Where necessary, a series of dams was constructed on long streams and the logs were floated or "driven" from pond to pond through dam after dam until they reached their destination.

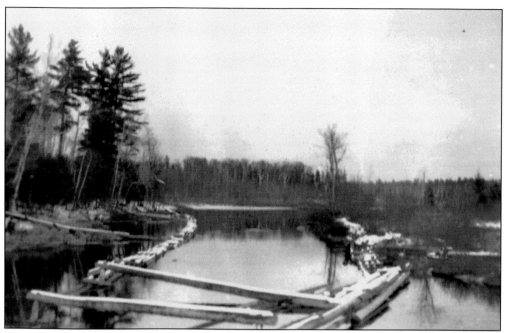
This photograph shows two side booms stretched along the shore to prevent logs from becoming stranded.

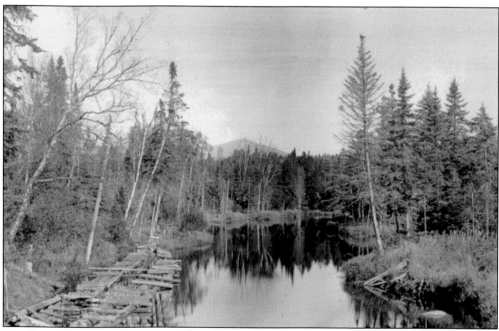
This boom was constructed to roll logs from the shore into the water. There is a gangway for the crew to walk along and cross logs placed, so logs may be rolled off with a minimum of effort. This was sometimes called a "rollway."

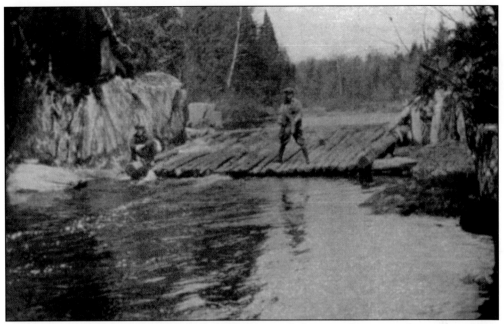

Here is an example of an apron built between two ledges to allow smooth passage of logs and prevent them from jamming at this narrow obstruction. If this stream was going to be used frequently and for a period of years, the obstruction would probably be blown out with dynamite. (From *In the Maine Woods*, 1927.)

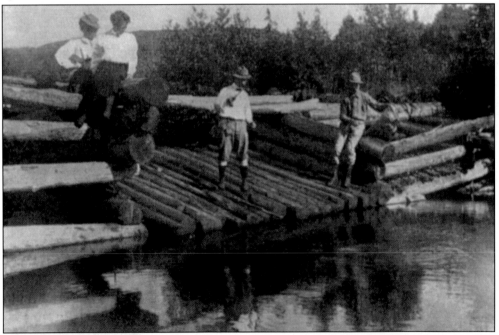

This apron was built between two cribs to narrow the area of passage and direct the movement of the logs. This would also confine the flow of water, thus increasing its velocity, giving the logs an extra "push," and avoiding the construction of another dam at this point. (From *In the Maine Woods*, 1909.)

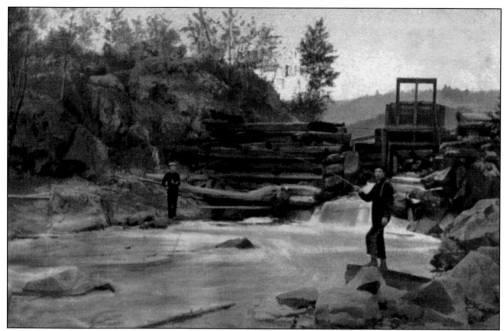

Here is a similar example to the foregoing, except this small dam has one gate in it to control the flow of water or stop it entirely to build up a head behind the dam. Rushing water generally carves out a substantial pool below such a dam, making an ideal spot for trout fishing.

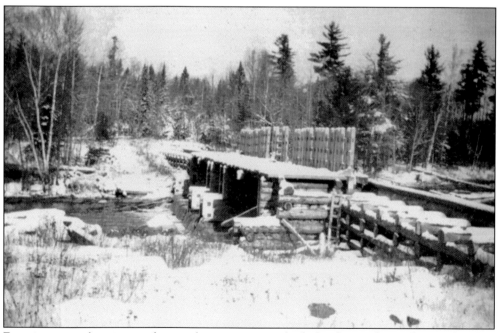

Even in remote locations, substantial structures were built for driving logs. This one has four double gates and rather lengthy wings, so it could undoubtedly impound a substantial volume of water.

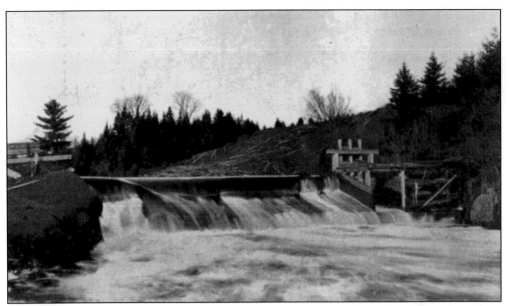

This dam was built on the Meduxnekeag River. It is obvious what it was used for, judging from the size of the landing just above it. One sluice gate can be seen on the right side.

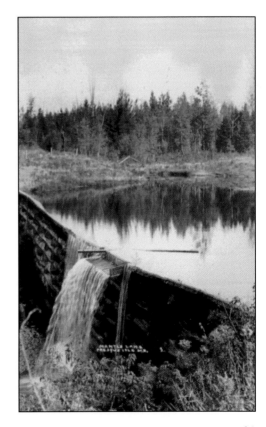

This is a rather small, fairly temporary structure used to hold back a head of water. It was probably used only a few times, perhaps just for one logging operation and then abandoned.

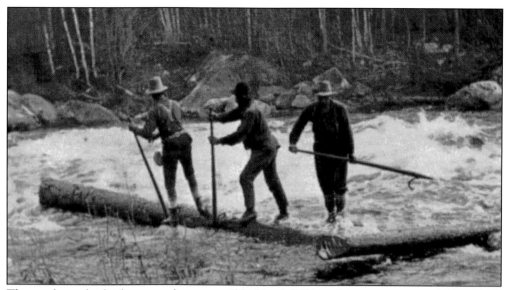

Those who rode the logs were known as "blackbirds." River drivers wore special boots with nails protruding from the soles, known as calked boots (pronounced "corked" boots). (From *In the Maine Woods*, 1938.)

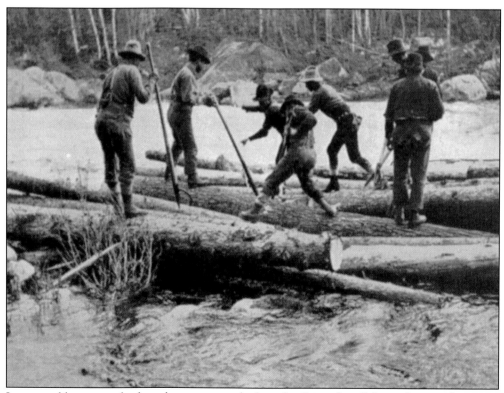

It was cold, wet, and often dangerous work, but the "river hogs" kept the wood moving downstream while they had high water. Here, a crew breaks up a small jam. (From *In the Maine Woods*, 1938.)

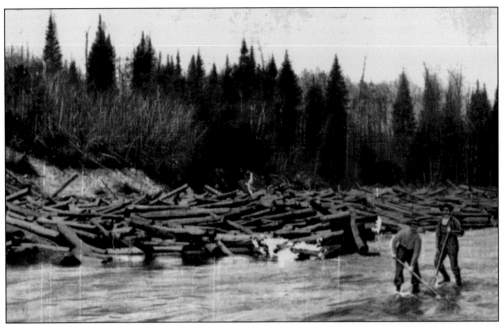

This job is called "picking up the rear." At the end of the drive, river hogs moved along the banks and in the water to loosen stuck logs, sending them on their journey downstream. It demanded being in the water, or at least wet, most of the time.

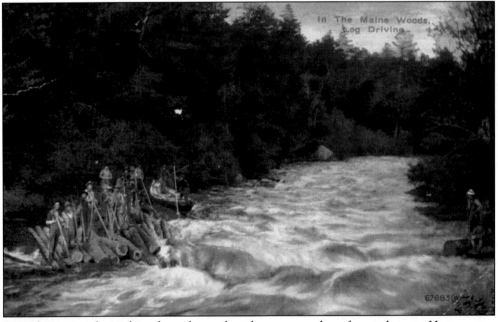

Some log removal was done from shore, though some was done from a bateau. Here, a crew attempts to free a jam of a couple dozen logs stuck on some boulders. If logs frequently jammed at one spot, a structure would be put in to divert them. Otherwise, dynamite would remove the obstruction, eliminating future jams.

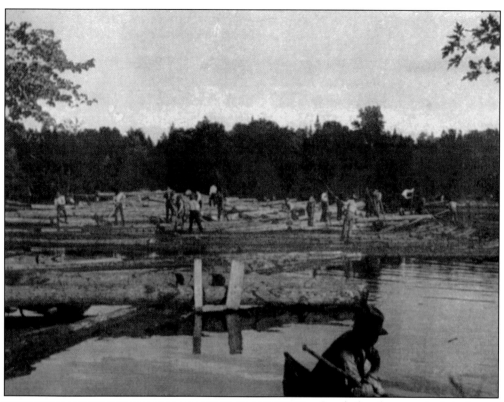

Just before logs reached their destination, they had to be sorted by ownership. Boom companies were responsible for getting everyone's logs downriver, to be separated at the end of the drive. Ownership of a log was distinguished with a mark similar to a "brand." Log marks were registered at the courthouse and are frequently found at the registry of deeds. (From *In the Maine Woods*, 1909.)

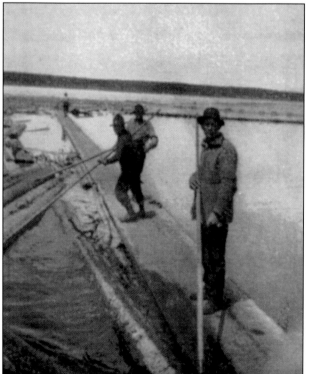

Here, river drivers are sorting logs and propelling them in the right direction, using pike poles. (From *In the Maine Woods*, 1915.)

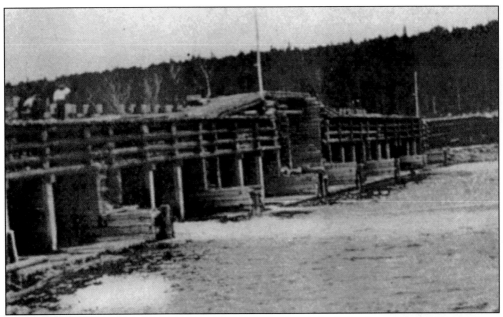

Long Lake Dam, one of several on the Allagash River, was built in the 1920s and washed out with the high water in the spring of 1960. As can be seen here, it was a substantial structure. The Allagash Dam Company was chartered by the legislature in 1851. (From *In the Maine Woods*, 1911.)

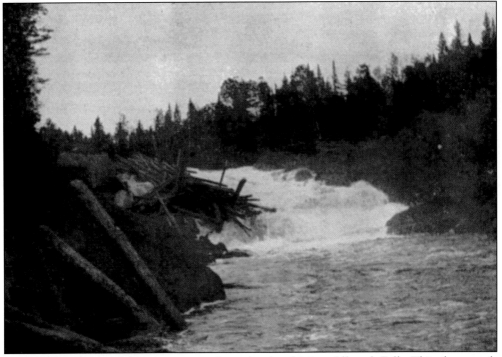

Farther down the river there was a major hazard to log driving, Allagash Falls. This photograph is a good indication of how logs do not always move freely over waterfalls, even though there is a pitch and the water is fast. (From *In the Maine Woods*, 1909.)

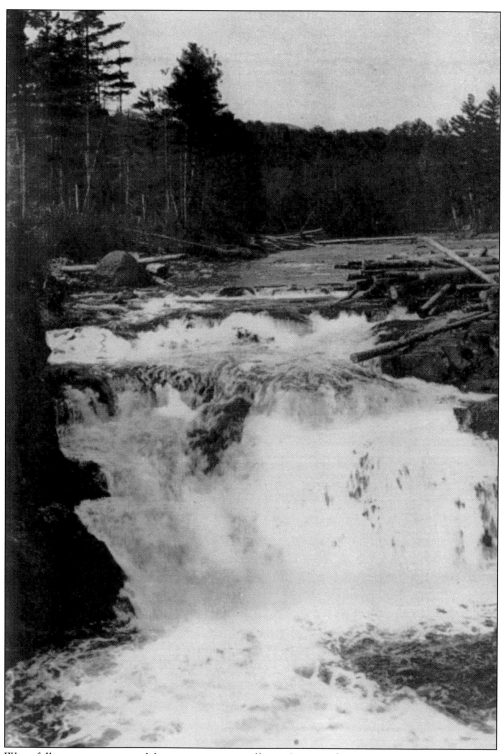
Waterfalls are common on Maine rivers, especially in Aroostook County. They always present a problem for log driving and result in jams, as seen here. (From *In the Maine Woods*, 1915.)

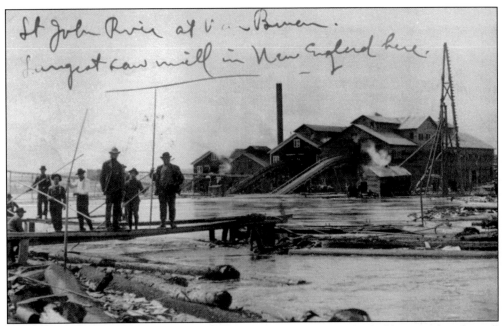

Here, rivermen guide the logs at the final stage of their journey, the holding pond at the mill where they will be processed.

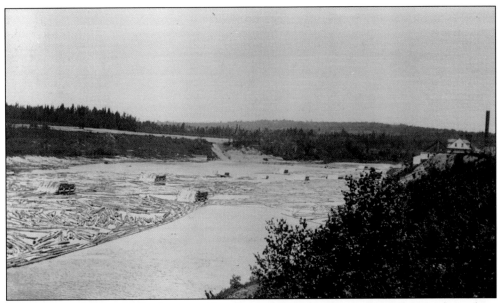

Aroostook wood went to Fredericton, New Brunswick, unless it was stopped somewhere along the way. The rivers in the northern part of the state flow north or east. Mills along these rivers were interested in the logs, such as this one in Ashland, but some wood continued on downriver and into Canada, where there was a large market for the timber.

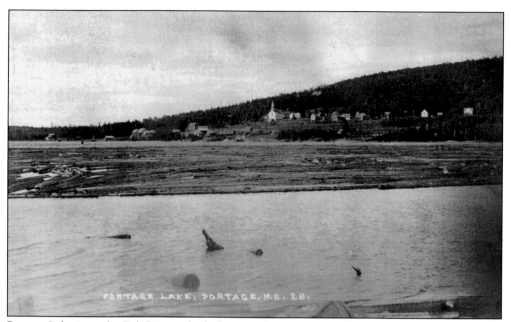

Portage Lake is on the Fish River, which flows north, intersecting the St. John River at Fort Kent. There were mills at Portage, so this raft of logs could have belonged there or could have been moved through the Fish River Chain of lakes to Fort Kent or beyond. (Steve Rainsford collection.)

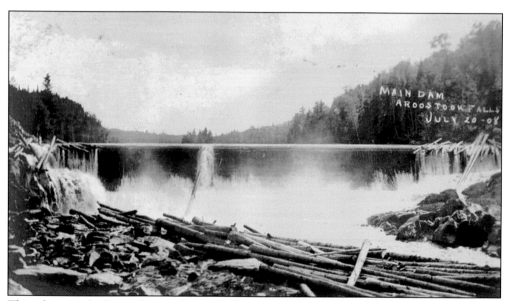

This photograph shows the number and character of logs that get "hung up" around dams, which must later be removed by hand and sent on their way downriver. The Aroostook Dam & Railroad Company was chartered in 1852. The Aroostook Boom was carried away by high water in 1854 and again in 1861, resulting in a considerable loss of logs.

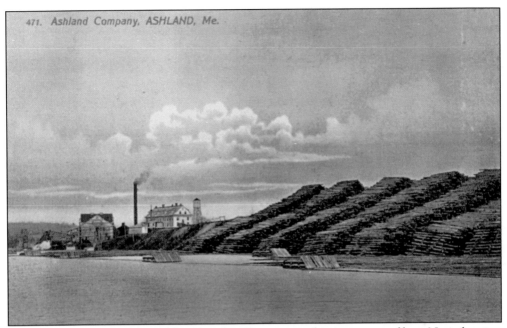

Here is another view of the Ashland Lumber Company and its inventory of logs. Note the piers that hold the booms, confining the logs toward shore and leaving the middle of the river free for the passage of logs to other companies farther down the river.

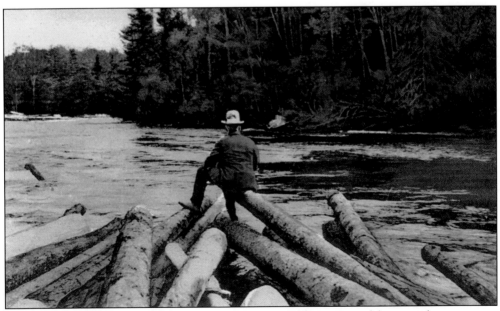

At Grand Lake Stream, an observer sits on a logjam and keeps a careful eye on the river.

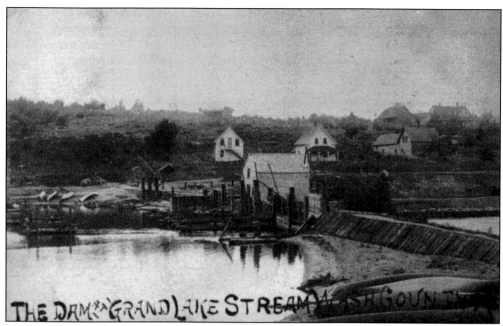

The Grand Lake Dam Company was chartered in 1846. In 1905, the water level of Grand Lake was raised seven feet by the St. Croix Paper Company.

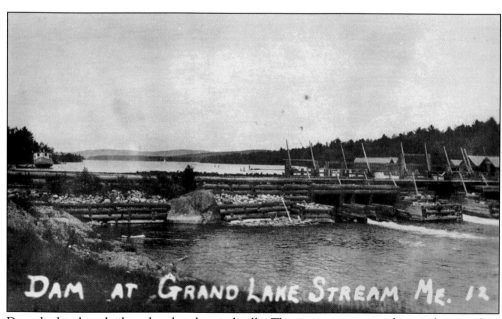

Dams had to be rebuilt and replaced periodically. This is a more recent dam at this site than above. Note the towboat anchored to shore on the left above the dam.

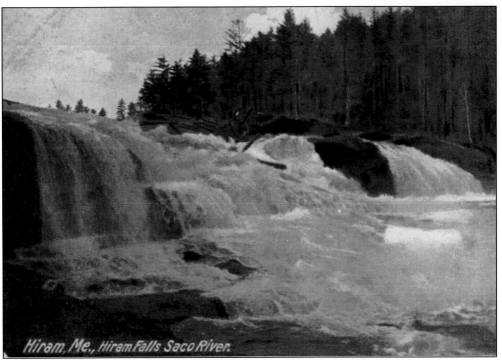

On the Saco River, Hiram Falls presented a problem and a potential site for a jam. Logs can be seen here jammed together, upstream of the ledge obstruction, in the middle of the falls.

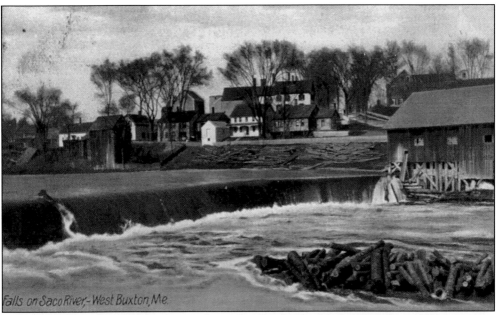

The Saco River was one of the first in the state to be developed, and as early as 1800 there were 17 saws above the falls. Here, a rollway is visible on the far shore above the dam, where logs are stacked on shore ready to be rolled into the river. Downstream a small jam of short wood awaits higher water or a river crew to send it on its way.

In this view of the Saco River, the crew is "bringing up the rear," a process whereby the remaining logs are freed from jams and from the shore. Here, one man steadies the bateau and keeps it headed into the current while the other attempts to free stuck logs. There are three additional workers on the cribwork ready to assist with their peaveys, or cant dogs. The Bar Mills Boom Company was authorized in 1824.

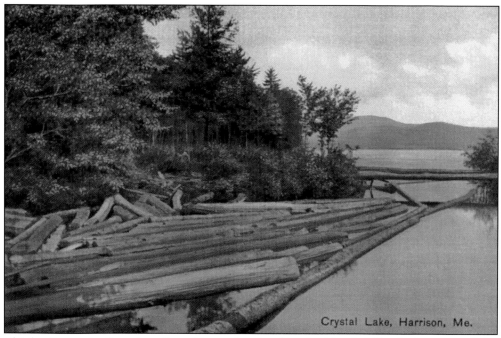

This landing and rollway has allowed logs to be placed in the lake, held by the booms until the time is right for transport downstream. From here, they could be moved through Long Lake and into Sebago Lake, depending on what mill they were going to.

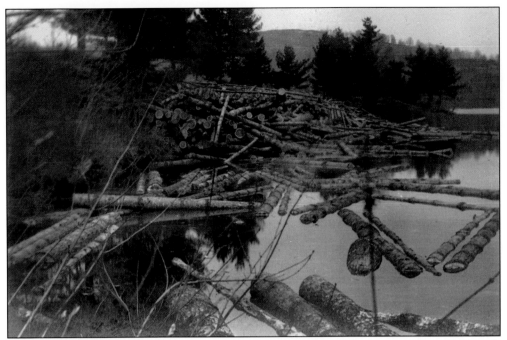

This is probably the Nezinscot River, which flows into the Androscoggin. The photograph shows the condition of the rollway, with pine logs in the process of being moved from land to water.

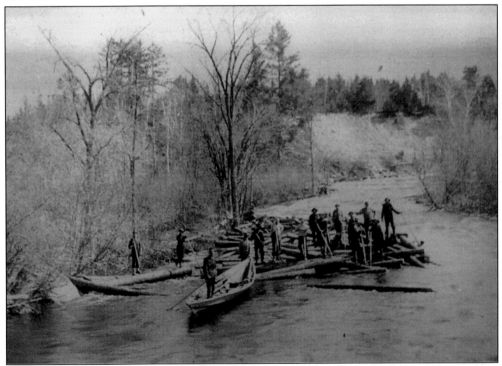

A crew prepares to break up a fairly sizable jam on the Webb River above Berry Mills Bridge. This river flows into the Androscoggin.

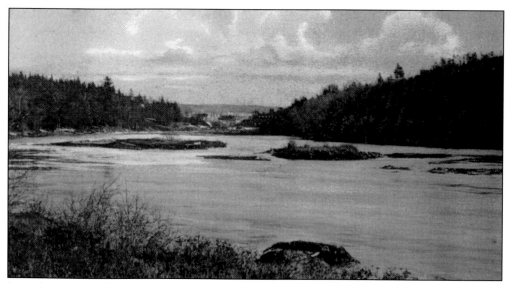

Logs driven down the Union River could reach tidewater at Ellsworth, second only to Bangor as a tidewater port.

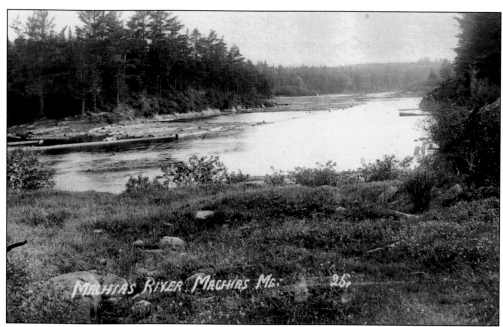

The Machias River was the scene of the last major long log drive in Maine. Here, logs can be seen confined to one side of the river by means of a boom strung for that purpose. Part of a log landing can been seen to the left, probably where the logs were placed in the river. The Big Machias Dam Company was founded in 1853 and the Machias Log Driving Company in 1854.

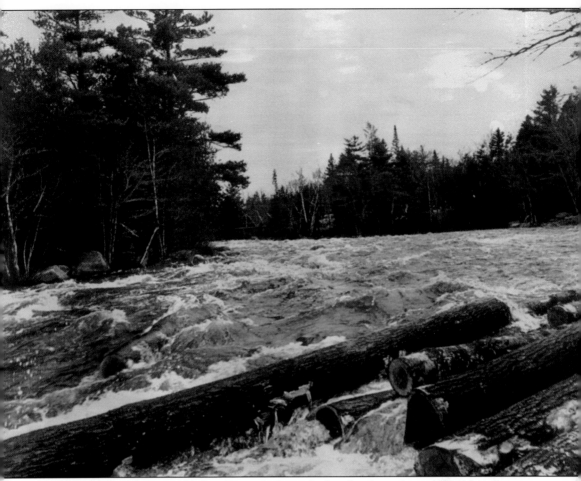
This photograph, taken in 1971 from Route 9, shows the last log drive down the Machias River.

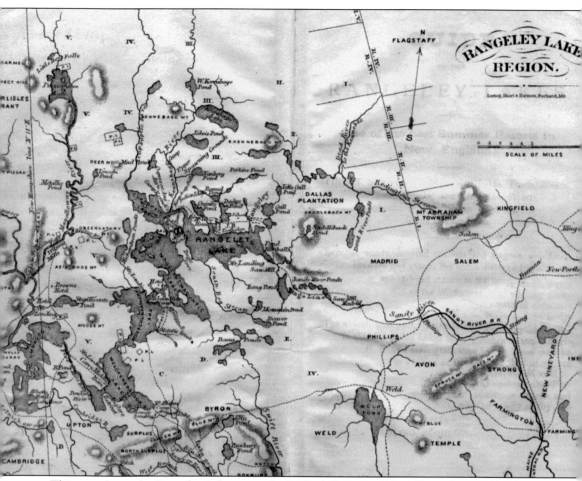

This map shows the Rangeley Lakes watershed, which flows into New Hampshire and back into Maine again. (From *Guide to the Rangeley Lakes*, 1880.)

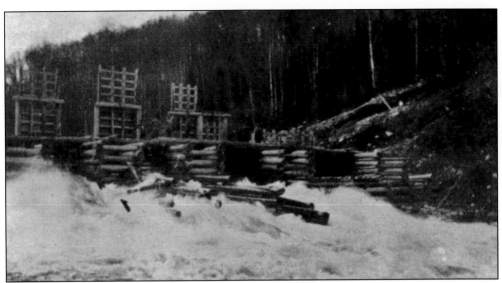

Parmachenee dam on the Big Magalloway River is releasing a large head of water, moving logs rapidly from the holding area to downstream locations. The river runs southerly from Parmachenee Lake to join the Androscoggin River above Umbagog Lake. The Magalloway River Dam Company was founded in 1861.

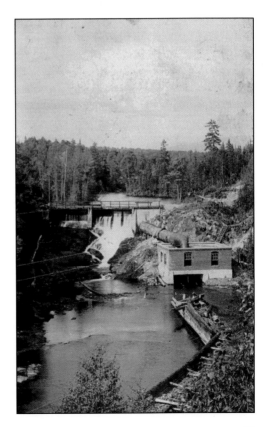

This is the dam and powerhouse at Kennebago Falls. Note the abutment on the right, built to deflect logs as they came through.

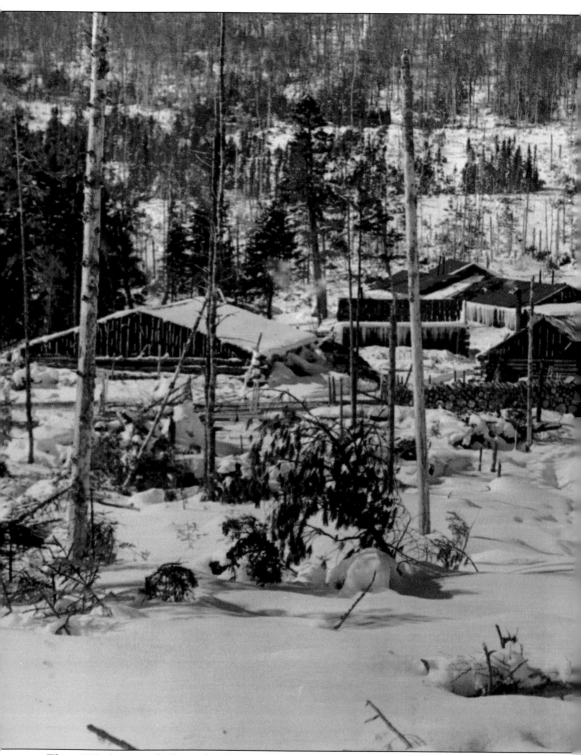

This 1929 photograph shows the Hastings Camps on Metalluk Stream. The array of buildings includes sleeping quarters, a cooking and dining area, plus utility buildings such as a hovel for

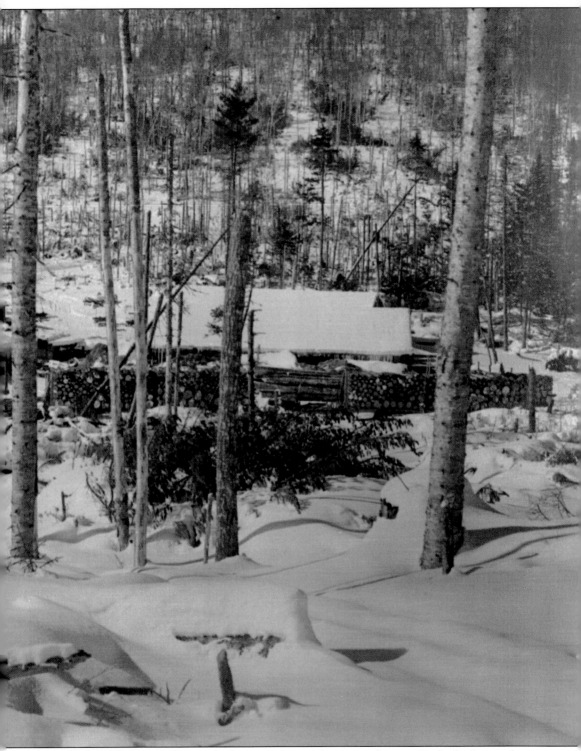
the animals, a blacksmith shop, a shed to store hay and grain, and so on. In the background, a substantial area has already been heavily harvested.

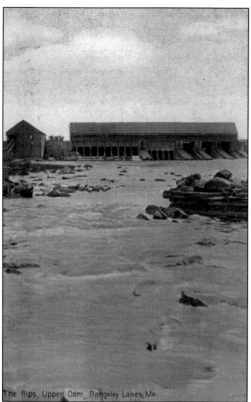

Logs cut in the upper headwaters of the Rangeley area found their way down the Cupsuptic and Kennebago Rivers into Cupsuptic and Rangeley Lakes, from which they were towed to Upper Dam. The sluiceways can be seen here toward the right side of the dam.

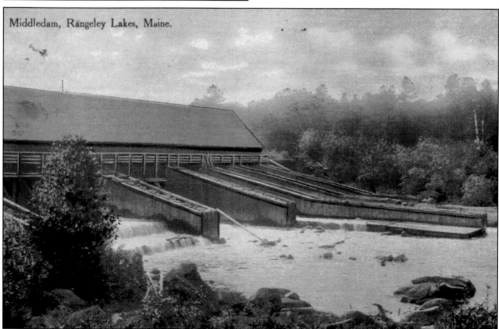

After Upper Dam, logs were towed across what is now Upper and Lower Richardson Lakes, sluiced through Middle Dam, boomed across Pond in the River, through Lower Dam and into the Rapid River, and eventually into Lake Umbagog.

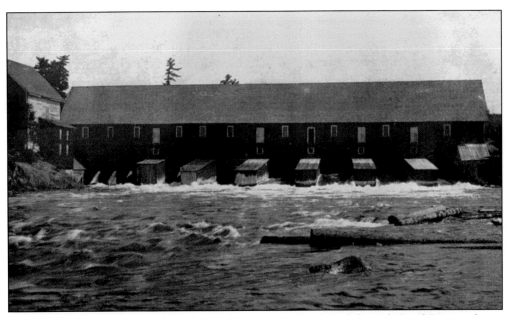

After being towed across Lake Umbagog, logs were again sluiced through Errol Dam and into the Androscoggin River.

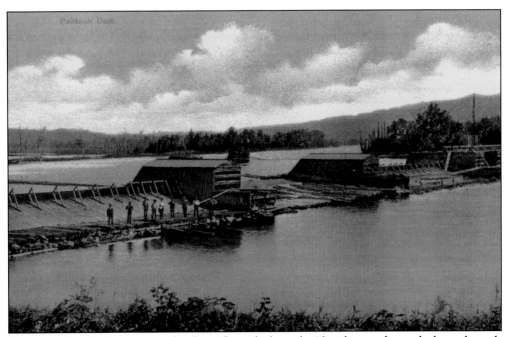

Once in the Androscoggin, the logs floated through 13-mile woods, and then through Pontook Dam and downriver to the mills at Berlin, New Hampshire, and Rumford Falls and Lewiston, Maine.

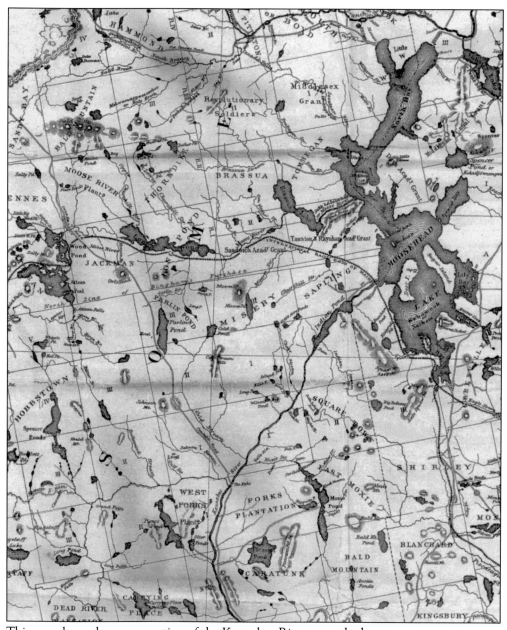

This map shows the upper portion of the Kennebec River watershed.

Three

THE KENNEBEC DRIVE

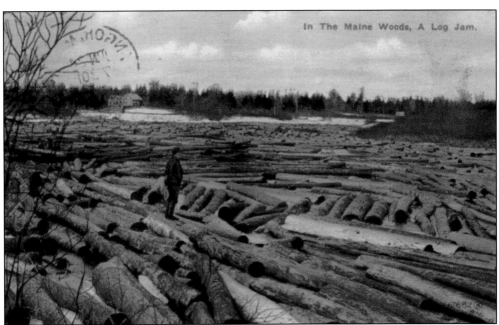

During one log drive, Milton G. Shaw's company sent eight million feet of long logs down the Kennebec River, all of which was rafted to the outlet by steamboat.

Second largest in the state, the Kennebec River drive continued for many years, first as long logs and later as pulpwood. The Kennebec Log Driving Company was incorporated in 1835.

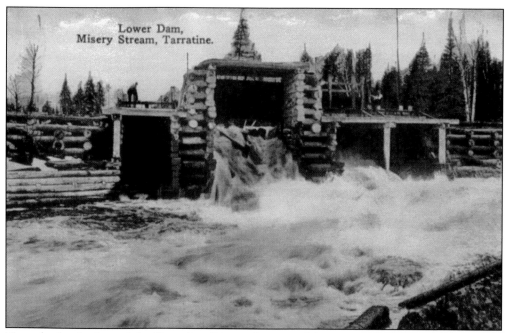

Near the beginning of the Kennebec River tributaries, Misery is one of the smaller streams around which vast areas of timberlands were cut. This dam is one of several on the stream and is significant for its rigid construction. Logs can be seen in the foreground as well as coming through the sluice gate.

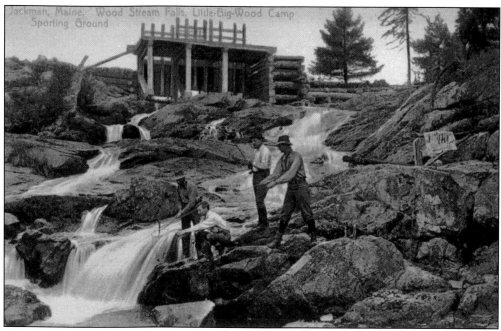

This dam is also on one of the Kennebec River tributaries, located on the headwaters of Moose River, near Jackman.

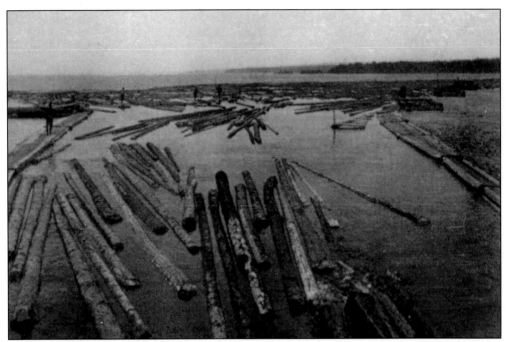
Spruce logs are being sluiced through the dam at East Outlet. Piers hold the fender booms in place on either side to funnel the logs toward the sluice gates. The crew keeps the logs moving and headed in the right direction using pick poles. Some walk the booms, while others ride the logs.

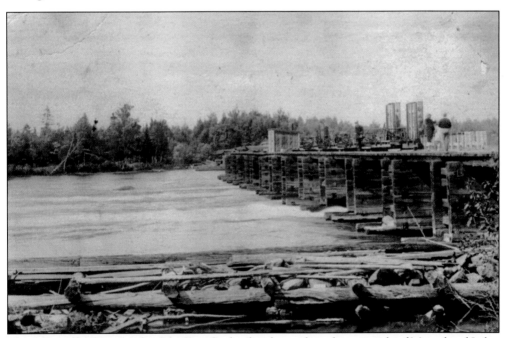
This is an early photograph of the East Outlet dam located on the west side of Moosehead Lake. Most of the gates are for the control of water. The sluice gates for this dam are on the farther side and not visible. In the foreground, the cribwork was built to keep logs away for the shore.

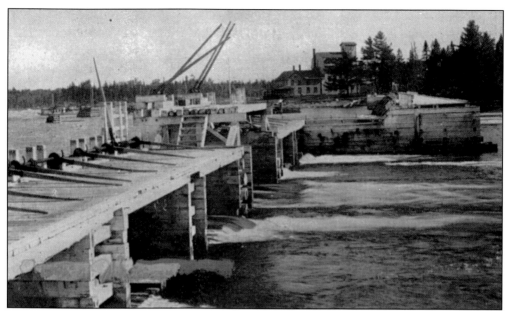

This view of the other side of the East Outlet dam shows the sluice gates. One of the logging boats can be seen in the background on the left, just beyond the piers. The Moosehead Dam Company was chartered in 1834.

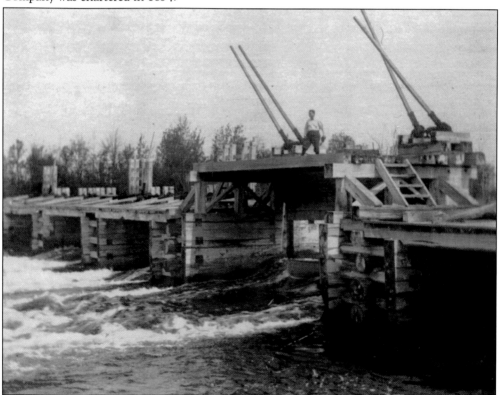

This is a close-up of the sluice gates at East Outlet dam. This section was removed c. 1947 and replaced with the concrete structure that exists today. It too contains two sluice gates.

Squaw Mountain, shown in this photograph, was the site of the first fire lookout tower in the United States, which was established in 1905. After several major burns of thousands of acres of timber, the state decided that preventative measures were in order and established lookout towers throughout the entire state.

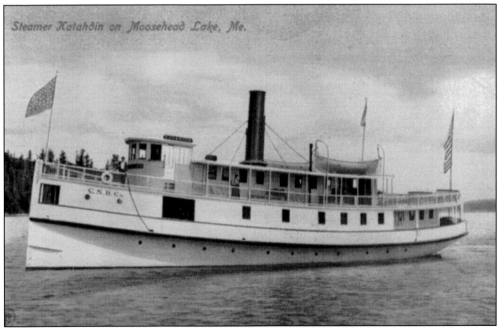

The *Katahdin* was one of a fleet of steamboats used to tow large booms of logs across Moosehead Lake to East Outlet dam, where they would be sluiced into the Kennebec River. This fleet was owned by the Coburn Steamboat Company. The *Katahdin* saw service for many years, later being used by the Hollingsworth & Whitney Company and then by the Scott Paper Company. It is now used for excursions around the lake during the summer months.

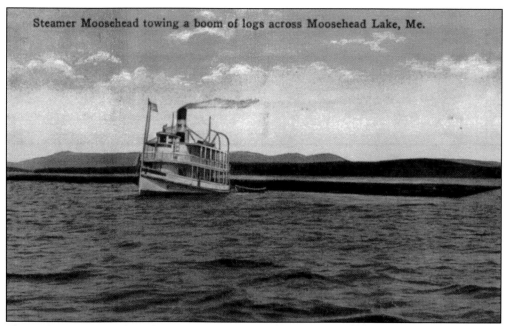

Shown here is a sister ship, the *Moosehead*, as it tows a raft of logs. Sugar Island and the Lily Bay Mountains are in the background. The ship was commissioned in 1848 and could make 14 miles per hour. In 1849, a newspaper reported that it had towed a raft of logs 21 acres in extent.

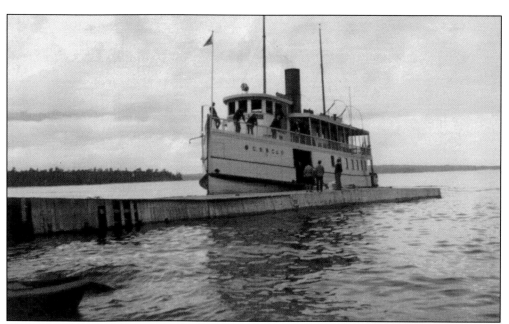

This is a close-up of the steamer *Moosehead*, as it sits at a dock awaiting the next assignment. After the towing season was over, these boats would take on passengers going to locations around the lake as well as take tours and excursions.

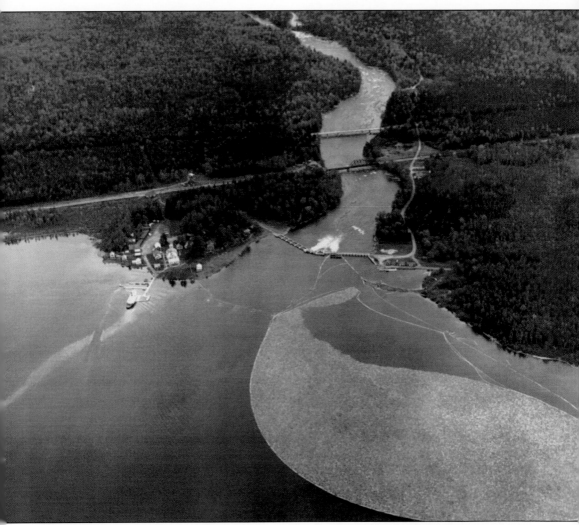

Shown here is one of the last pulpwood drives at the East Outlet dam. The wood is contained within the boom, held in place by being anchored to the piers. Boom logs can be seen in place to funnel the logs toward two sluice gates. The intermediate boom between the main enclosure and the dam is known as a "gate boom." The towboat, the *Katahdin*, can be seen tied at the dock to the left. The last year for driving pulpwood in Maine was 1975.

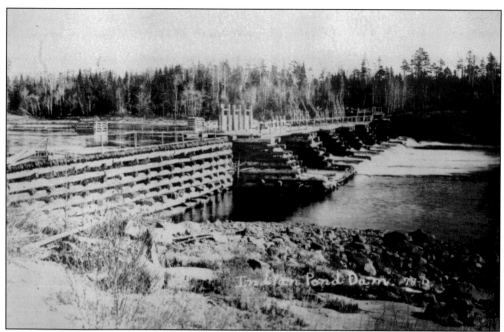

One of the more substantial dams on the Kennebec River was this one at the foot of Indian Pond. It was replaced in the mid-1950s with a much larger structure built farther downriver. It has a head of 110 feet and impounded an area at least three times what the above dam flooded. The Indian Pond Dam charter by the Kennebec Log Driving Company was issued in 1847.

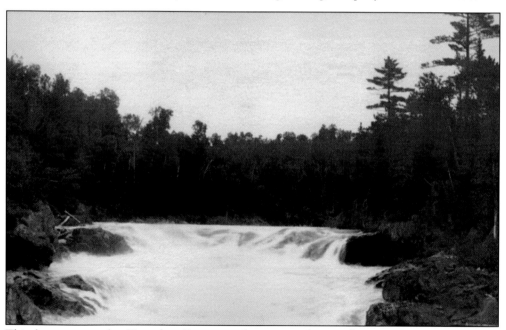

This location on the Kennebec River was known as the "Hulling Machine" or "Hulling Machine Rips." It was said that the river was so violent at this location that no log ever came out with its bark still on, which saved debarking at the mills downriver. The rips were flooded out with the construction of Harris Dam at the lower end of what is now Indian Pond.

Moxie Falls, near the Forks, is on Moxie Stream, which flows into the Kennebec River. It has been said that when pulpwood was driven down Moxie Stream, it would often jam back clear over the top of the falls, more than 90 feet.

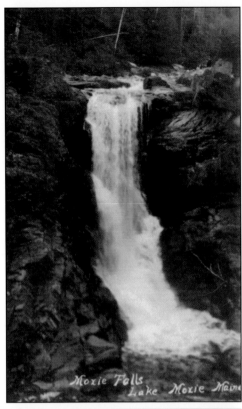

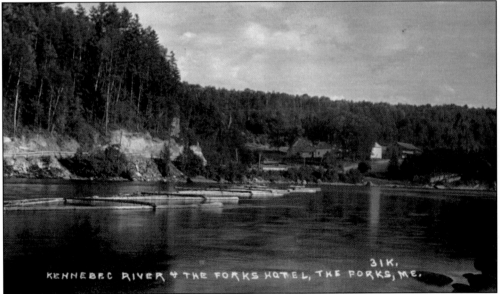

The Dead River flows into the Kennebec River at the Forks, draining a large area to the west, including Flagstaff Lake. In this photograph, a fin boom can be seen on the left, placed to guide logs and keep them away from the shore and in the center of the current. These are less expensive to install than abutments or long booms attached to piers. The Dead River Dam Company was founded in 1843.

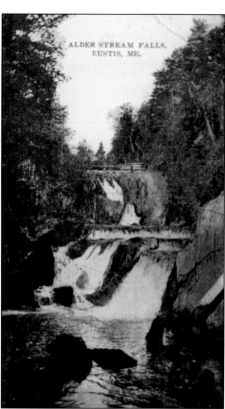

Alder Stream is a tributary to Dead River. In this photograph, a wooden structure can be seen just upriver from the falls, placed to control logs and prevent jams.

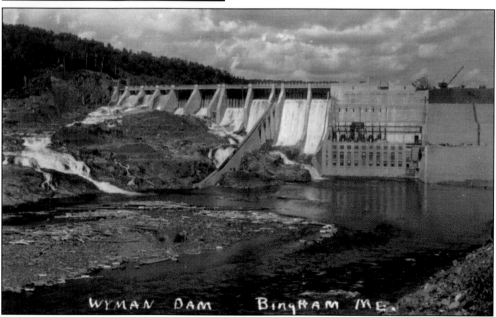

Below Indian Pond, the next impoundment and dam is known as Wyman. It is a large power dam like Harris Station at Indian Pond. This photograph shows the sluice in the center of the dam for getting the logs through. Since the water is low in this photograph, a number of logs can be seen stranded on the gravel bar in the foreground.

Sandy Stream flows into the Carrabassett River and becomes Gilman Stream, which in turn flows into the Kennebec River at North Anson. Here, a sizable raft of logs has been dumped from shore and awaits a freshet to move it along.

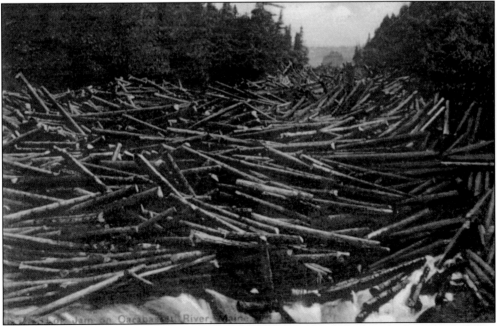

When too many logs are moved too fast at one time, which was frequently the case, and they meet an obstruction, a considerable logjam can result. This one would be called a "solid jam," since it extended from bank to bank. A jam of this magnitude could take days, even weeks, to unravel.

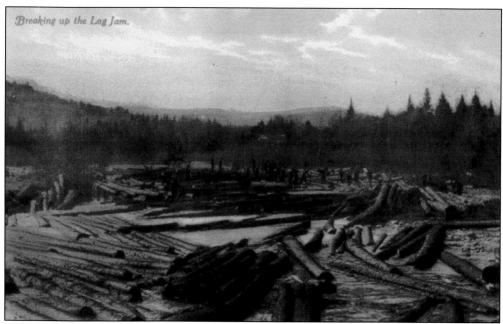

When a jam does occur, large crews must get out on the logs and move them around, freeing them, until the key one or two are loosed, thereby breaking the jam. It was dangerous work and there were frequent drownings and injuries. When a jam could not be broken by hand, it was dynamited, a dangerous alternative as well.

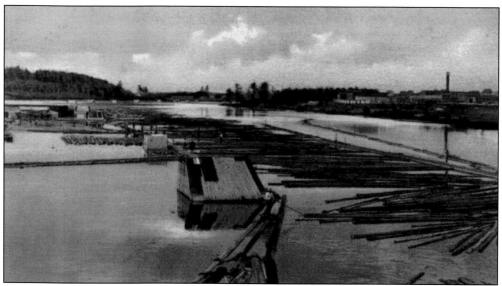

Farther down the river, as the mills were reached, logs were stored in sorting booms, as seen here. Some sorting has been completed here, evidenced by the bunches of logs seen upstream. Note the long string of piers extending upriver and the parallel booms on the right, known as "fender booms" or "sheer booms." They guide the logs to the sorting gap, where they are separated according to ownership.

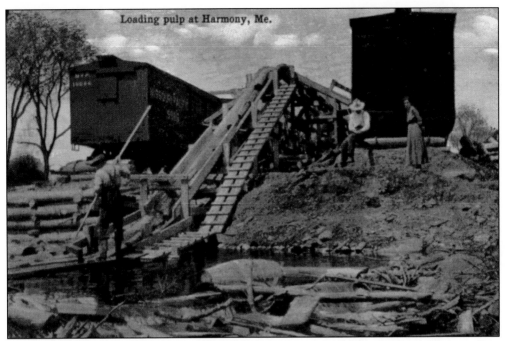

Here, a worker with a pick pole is guiding logs to a conveyor, which transports them to where they can be loaded onto railroad cars to take them to a mill. The man at the top of the hill is keeping a tally of how many logs are moved according to kind of wood (tree species).

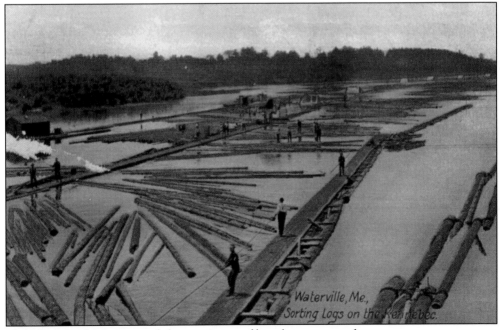

This photograph gives a much better picture of how logs are sorted.

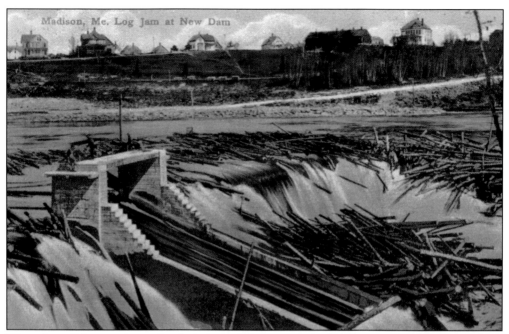

These logs did not quite make their intended destination: the sluiceway at the front of the photograph. They are jammed up all over, including at the foot of the dam itself.

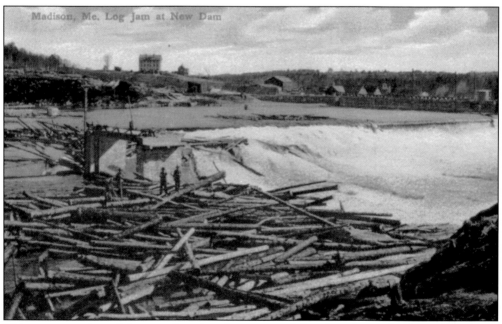

This upstream view of the same location shows some of the obstacles to the drive. The rest of the dam is to the upper right and is mostly log-free, showing how the logs have been directed to this location, so they could be sent down the sluiceway.

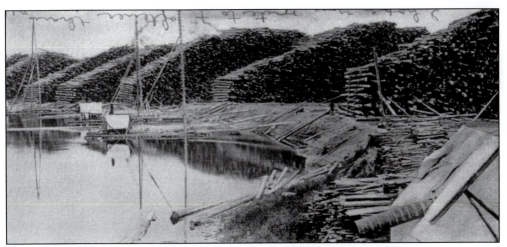

This is at one of the mills in Madison, showing a tremendous inventory of logs.

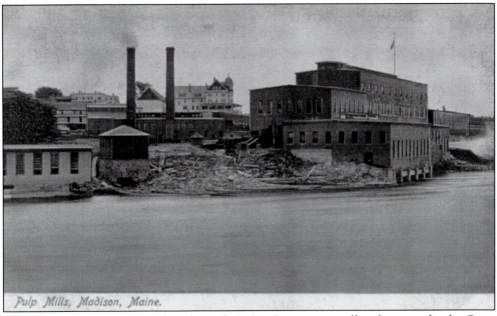

Pulp Mills, Madison, Maine.

This pulp mill was constructed in the early 1890s. It was eventually taken over by the Great Northern Paper Company.

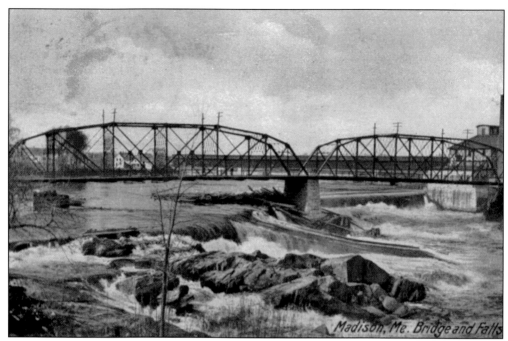

Another obstacle to log driving is a bridge. Note the piers and booms that direct logs toward the sluice built in the middle of the falls.

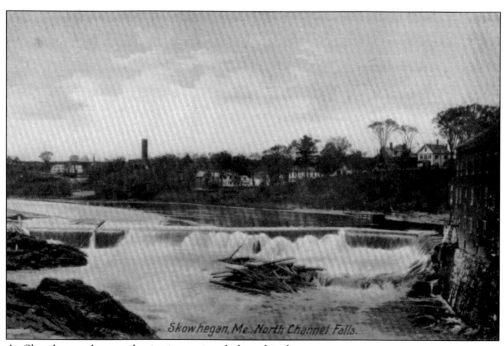

At Skowhegan, logs are beginning to jam below this dam.

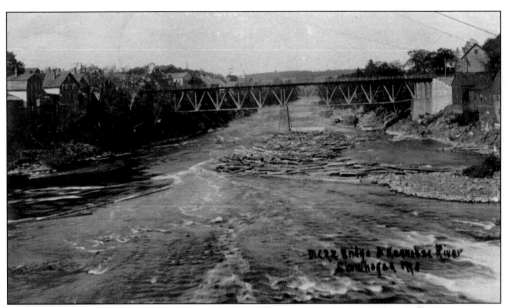
Bridge abutments almost always cause logjams. Some were substantial, taking days or even weeks to take apart.

Side booms keep logs away from the shore and out in the current, where they will keep moving.

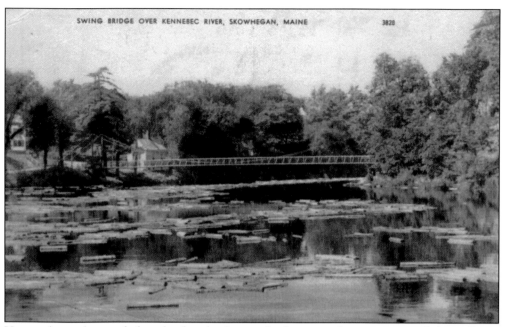
Here, pulpwood extends from bank to bank, as it slowly moves downriver toward the mill.

Here is another view of side booms and their effect on moving logs, which can be seen near the middle of the photograph.

Martin Stream is southeast of Norridgewalk. It flows into the Kennebec River between Skowhegan and Waterville. Here, log drivers work to free logs from the top and the base of the dam.

These logs have finally made it to their destination, a cove where a sawmill is located. They will be kept here by what is known as a "gate boom," strung across the mouth of the cove and attached to piers to keep them from floating away.

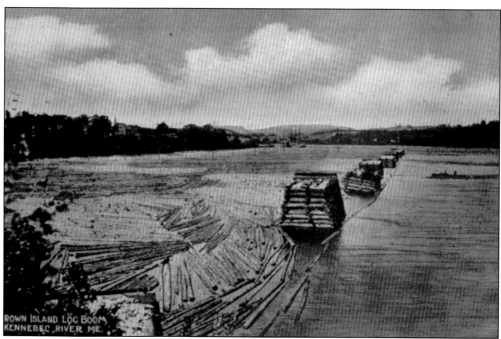

This photograph, taken near Gardiner, is a good example of a large boom collecting and confining thousands of logs. The sorting area is above here, near the center of the photograph. The Brown Island Boom was sanctioned by the legislature in 1835.

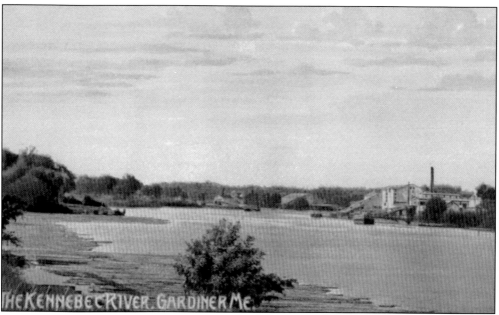

Here is another view of the river, showing at least two mills on the opposite bank. Logs are stored on the near side in a protected cove, leaving the main river open for traffic. The lower ends of rivers were sometimes cursed by extreme high water. In 1832, all the booms broke. In 1839, the Kennebec Dam was undermined. In 1845, a flood caused "immense quantities" of lumber and vessels to be carried into the streets of Augusta.

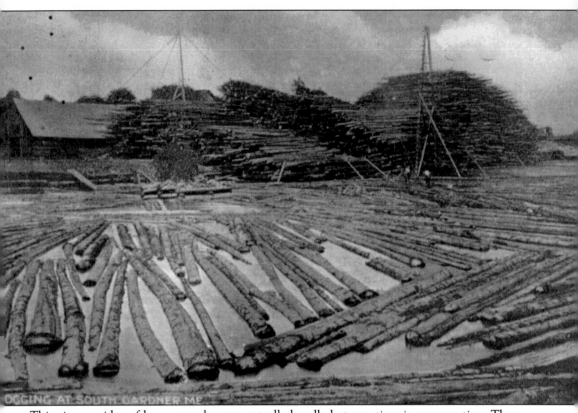
This gives an idea of how many logs are actually handled at one time in an operation. These rollways are ready to be dumped in the Kennebec River. Two drivers move logs away from the shore in order to roll more in.

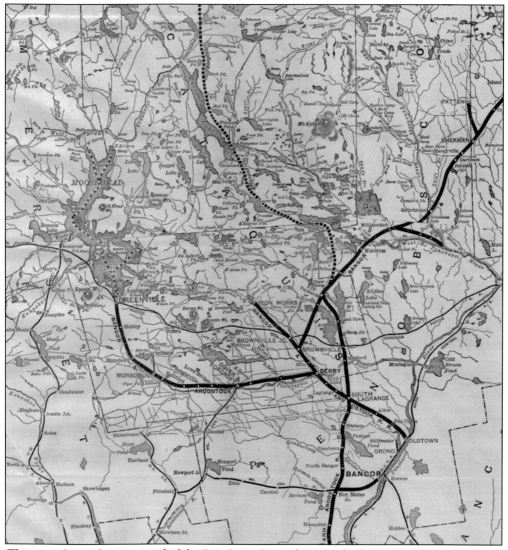

This map shows the upper end of the Penobscot River drainage, both East and West Branches.

Four

THE PENOBSCOT DRIVE

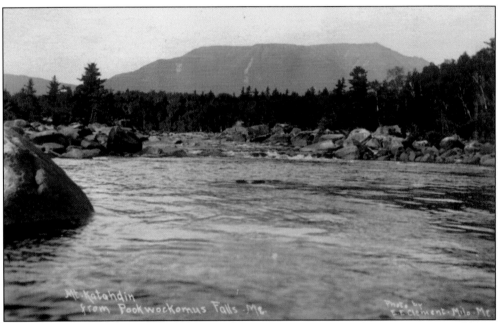

The Penobscot Basin is the largest lying wholly within the state of Maine. Two principal parts, the East Branch and the West Branch, unite to form the main river at Medway. The West Branch begins near the boundary of Canada and flows eastward, while the East Branch drains the Katahdin area. Leading tributaries are the Piscataquis and the Mattawamkeag Rivers. There is no large lake in this drainage, but it has been written that there are 1,604 streams and 185 lakes that give rise to this river system. Originally, the Chamberlain and Telos Lake areas were tributaries to the St. John Valley, but this was changed in 1840 with the building of the Telos Canal, diverting their waters into the Penobscot system. This is yet one more example as to the length lumbermen will go in order to achieve their goals. The Penobscot Log Driving Company was chartered in 1846, giving rise to one of the most famous and significant of all lumber operations, especially log drives. This photograph shows a typical section of the Penobscot River, with Mount Katahdin in the distance.

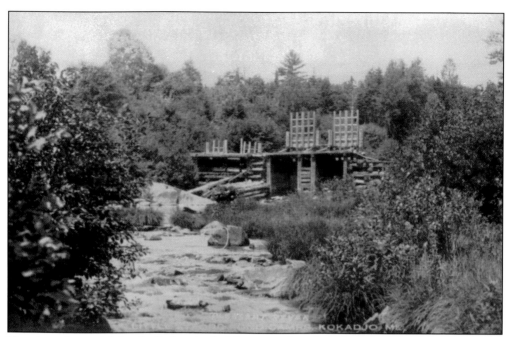

Here is a substantial dam built deep in the Maine woods and on the Penobscot River watershed. This one is located on the Pleasant River, a tributary to the Piscataquis River, which in turn flows into the Penobscot River at Howland.

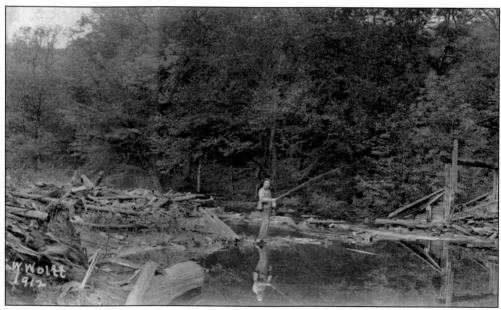

This photograph of a fisherman was taken in 1912. Also shown are the remains of a dam as it existed then, providing a clue as to how early massive logging operations existed in this area just south of Moosehead Lake, but on the Piscataquis River watershed.

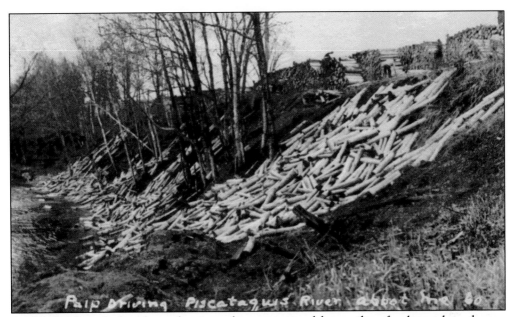

At this landing, farther down the river, there are several large piles of pulpwood on the top of the bank ready to be pushed into the river. Once the water rises, either through natural or artificial means, the wood will be washed downstream to its ultimate destination of some processing mill. This is also known as a "high rollway."

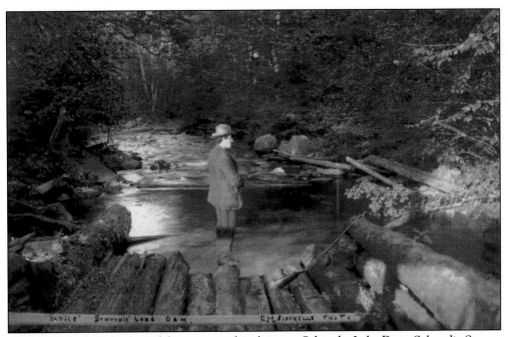

A hunter stands at the foot of the apron at this sluice on Schoodic Lake Dam. Schoodic Stream flows into the Piscataquis River, which in turn flows into the Penobscot River.

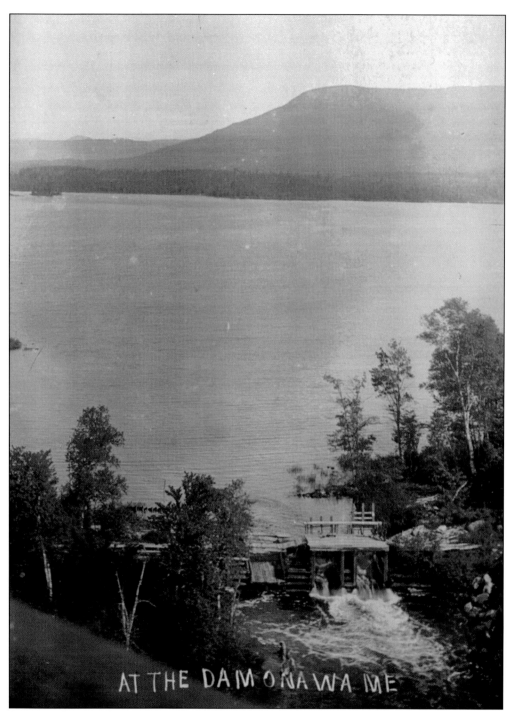

Onawa Lake was the site of a number of logging operations just southeast of the Moosehead Lake area. While the Kennebec River flows southwest out of Moosehead to the ocean, Ship Pond Stream begins here and flows southeasterly into Sebec Lake at Bucks Cove, where it then becomes the Sebec River, flowing into the Piscataquis. The sluiceway in this dam can be seen to the left of the two main gates. The Ship Pond Stream Dam Company was founded in 1853.

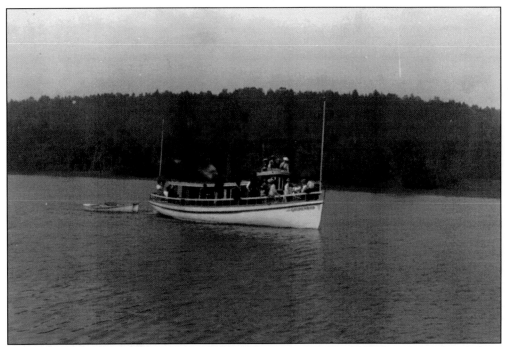

This boat, the *Goldenrod*, was used on Sebec Lake to tow booms of logs. It is shown here taking passengers on a tour around the lake. Capt. Ansel Crockett and his son Fred commissioned this steamer c. 1899. The steamer was 60 feet long and charged $2 per hour for towing. (Steve Rainsford collection.)

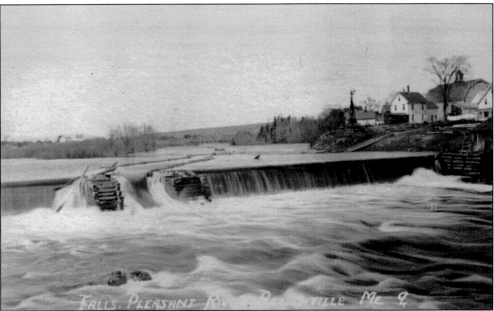

The Pleasant River also flows into the Piscataquis River and eventually into the Penobscot River. This is a nice photograph taken at Brownville, looking upriver showing piers, fender booms for guiding logs to the sluice, and on the right, a landing where logs are dumped into the river. The Pleasant River Dam Company began in 1852.

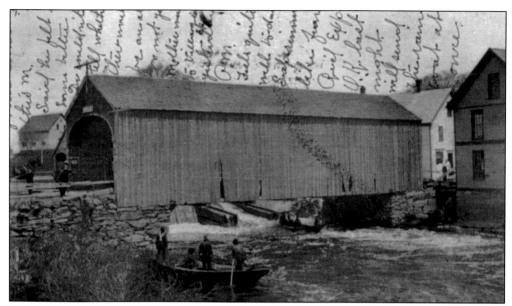

Farther down the river, crews are helping to keep logs moving through the sluice and on their way downstream. As seen in other photographs, this is an easy location for logs to jam. (Steve Rainsford collection.)

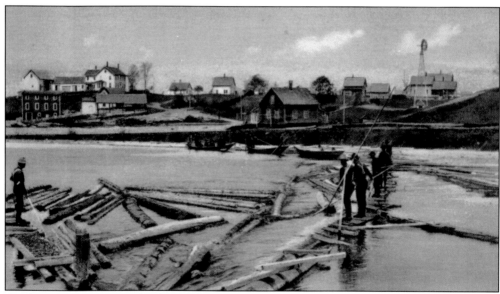

On the Sebec River at Milo, these crews guide the logs through the sluice during a heavy pitch of water. Some of the men are using peaveys while others are using pick poles. The river joins the Pleasant River just south of town and then flows easterly to join the Penobscot, intersecting the Schoodic River and the Seboeis River on its way.

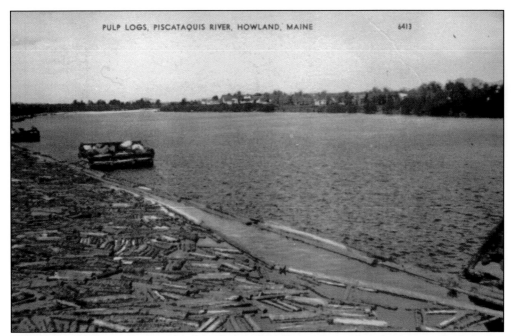

This is a more recent photograph taken during the pulpwood era. Here, booms attached to piers confine the wood to the shore. There may be a pulp mill at this location whereby the logs will be processed here, or this may be a mechanism for moving the logs on farther to the mills at Old Town. Note that there are actually three strings of logs making the boom, so if logs should escape the inner one, they will hopefully be contained by one of the outer ones.

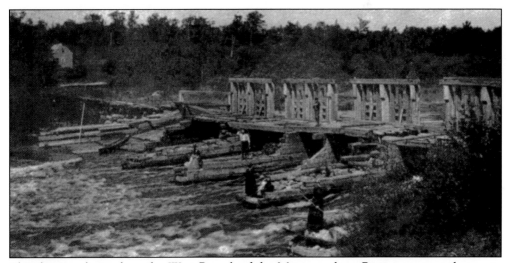

This dam was located on the West Branch of the Mattawamkeag River, a major tributary to the Penobscot River. Again, this photograph shows what a popular fishing spot these dams were when logs were not being moved through. The Mattawamkeag Lake Dam Company was founded in 1860.

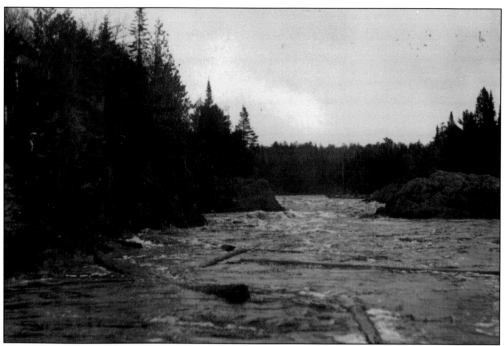

This photograph shows logs in the Mattawamkeag River and nicely demonstrates the rough character of the river itself. A boom was authorized by the legislature for this river in 1856.

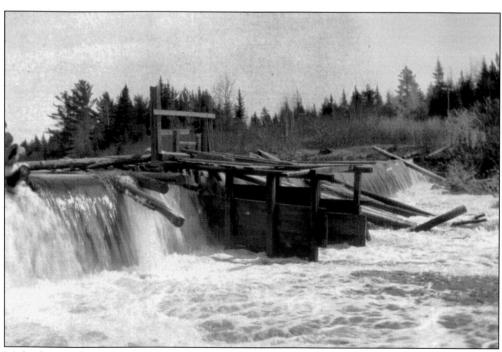

Molunkus Stream is a tributary to the Mattawamkeag River. A one-gate dam with a prominent sluiceway here has a number of logs hung up both upstream and down.

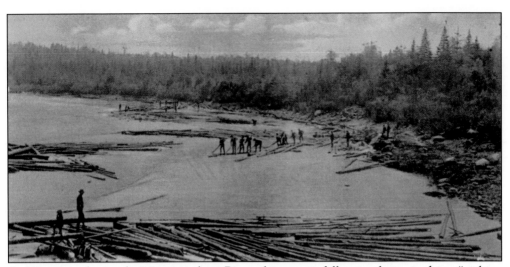

At Kingman, also on the Mattawamkeag River, this crew is following the main drive, "picking up the rear." It took a sizable crew to clean up jammed and otherwise stranded logs, which had to be moved out into the main current one at a time.

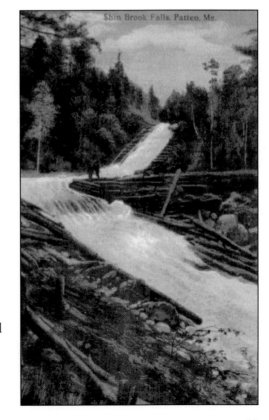

This flume was built to overcome the problems associated with Shin Brook Falls. Note the smooth gradient and route of travel with this type of modification. Many were built off to one side of the river channel, or independent of the streambed. This one incorporates the streambed itself into its design.

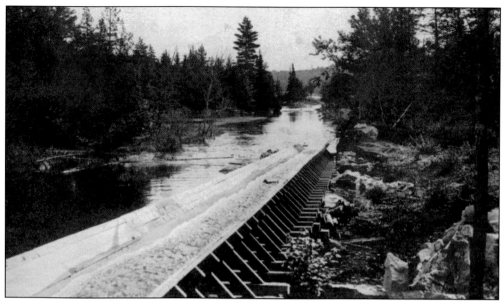

The flume, also known as a chute, at this location was constructed on the side of the river, and the flow was diverted into the trough as the need arose.

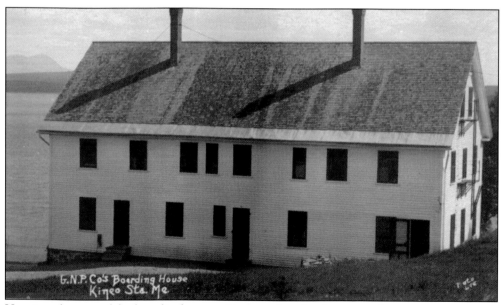

Here is a close-up of the boardinghouse at Rockwood used to house workers: cutters, teamsters, and river drivers.

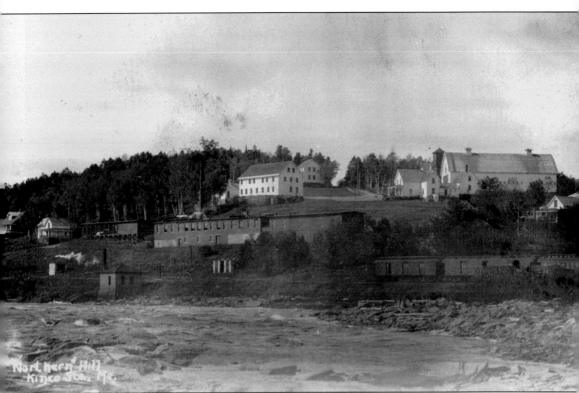

This is a shot of the Great Northern Paper Company's operation at Rockwood, which supported its many crews operating to the north. Housing, maintenance shops, a barn, and office buildings were all part of the headquarters area shown here. Homes for the staff are also located nearby, along with the main shop building in the foreground, the boardinghouse in the middle, and the barn on the right. The barn was used to house and feed horses. A road was built from here northward to Seboomook and beyond during 1909–1915. It was constructed from Seboomook to Pittston Farm in 1910. By 1916, the Great Northern Paper Company had as many as 60 four-horse teams working in the woods. The Maine Central Railroad reached here in 1904, and Rockwood became a main hub for logging operations in this area.

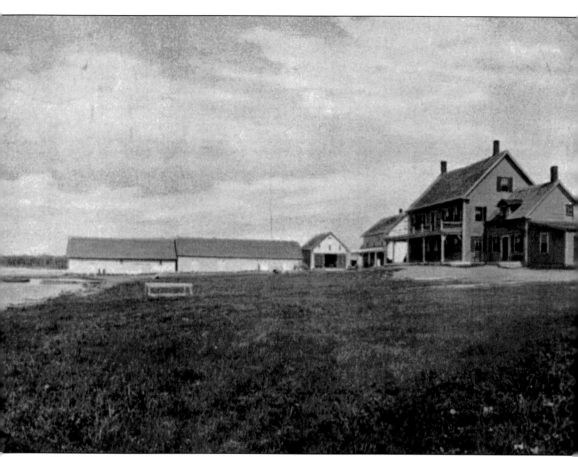

Several lumber railroads were chartered by the state. One of them was between Bangor and Old Town in 1832, the Whitneyville and Machias in 1836, and the Moosehead Lake Railway in 1847. This latter railway ran from here at Northeast Carry to the West Branch of the Penobscot River. The track was originally made of straight pine logs, which were later replaced with iron. Fires started by blueberry pickers in 1862–1863 destroyed the railroad. Another railroad, the Seboomook and St. John Railway, called "the railroad that went nowhere," was built in 1919–1921 and ran from Seboomook Lake 12.5 miles north to the St. John Ponds area. Only a small amount of wood was hauled for a very short period of time, and the railroad was abandoned in favor of alternative methods of moving wood. Later railroads were established in the Jackman-Kennebec region in the early 20th century. They proved to be very successful.

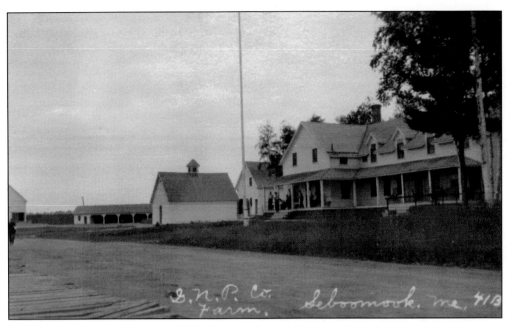

Farther up into the big woods from Rockwood, the Great Northern Paper Company, known as "the Northern," established a number of farms to support their men and horses. This one was located on Moosehead Lake at Northwest Carry, not far from the Penobscot River. The first Seboomook house was built in 1835 and was purchased by the Great Northern Paper Company in 1899. The farm as shown here was constructed in 1910–1917.

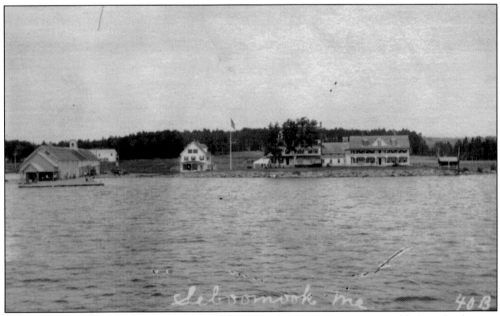

This is a view of the farm from the lake. The wharf and storehouse were added to the farm in 1922. Farms such as this grew oats, hay, potatoes, and vegetables. They also wintered horses and provided lodging for the logging crews.

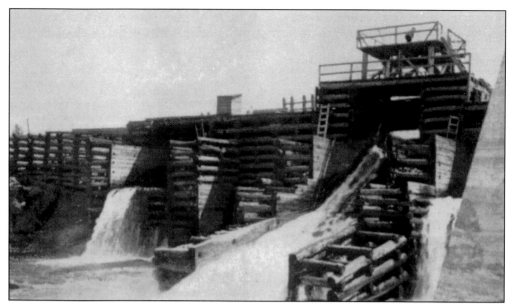

Farther up the Penobscot River, on the South Branch, a dam was built at Canada Falls. About 1927, the existing wooden structure was replaced with the concrete structure that exists there today. (From the *Northern*, January 1927.)

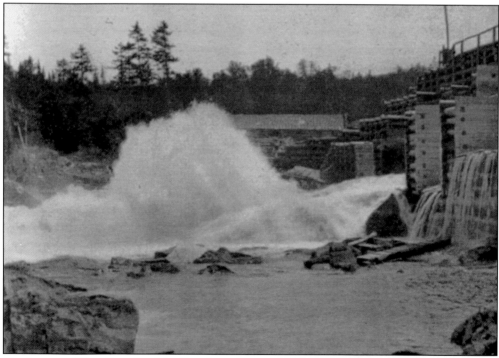

On the main West Branch of the Penobscot River, the Great Northern Paper Company built this dam in 1913–1917 at Seboomook Falls, creating what is now Seboomook Lake. This dam, built on the foundation of a previous dam, was 808 feet long and had a head of 28 feet. It contained eight shallow gates, four deep gates, one log sluice, three spillways, and a dri-ki sluice. (From *In the Maine Woods*, 1915.)

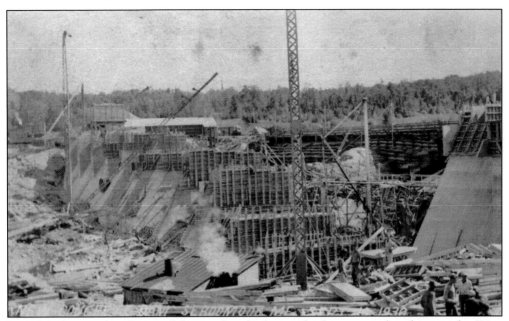

In 1936, the wooden dam at Seboomook, which was the largest wooden dam on the West Branch, was replaced with a concrete structure. This location was also known as Henderson's Pitch because a man named Henderson lost his life here.

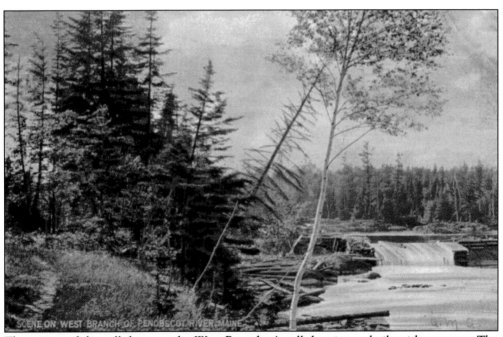

This is one of the roll dams on the West Branch. A roll dam is one built without gates. The logs floating over the dam caused a roll after which the dam was named. The path on the left is one used by river drivers and others as they walked up or down the river. It is known as a "gig trail." This one still exists and is regularly used by fishermen.

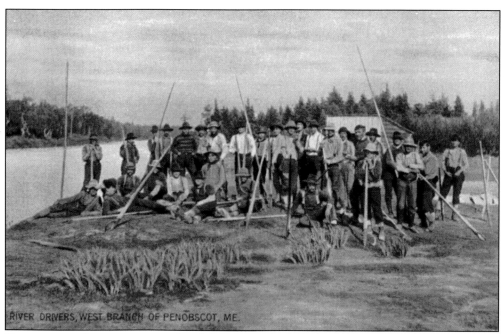

Here is a typical river crew armed with peaveys and pike poles. Note the length of the handles on the various tools.

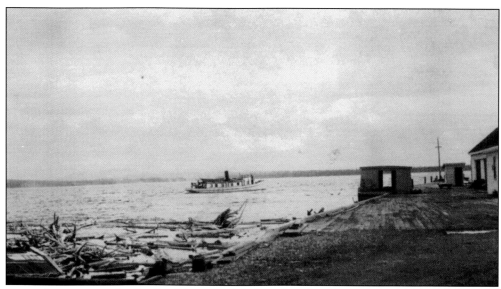

Down the river several miles lies Chesuncook Lake, where logs had to be towed from the mouth of the Penobscot River to its continuation at the foot of the lake. This is a photograph of one of the towboats, the *West Branch No. 3*, used on Chesuncook Lake for moving rafts of logs.

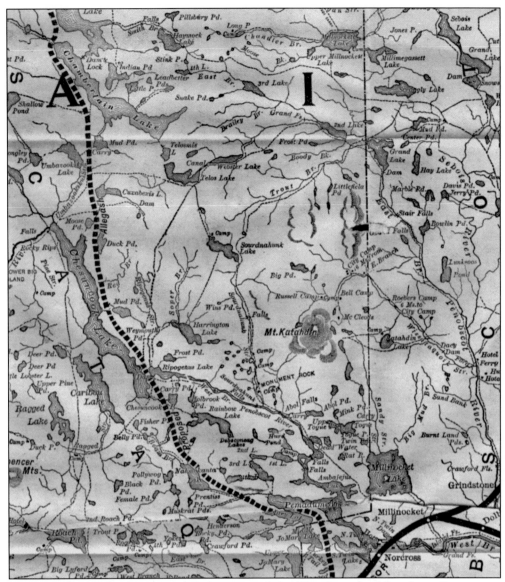

This map depicts the Chesuncook Lake area and the West Branch of Penobscot River to its south. There are several dams and a canal shown on the map, along with log-driving hazards, such as falls. This shows the concentration of bodies of water and how they were used to advantage in moving logs from the woods to the mills.

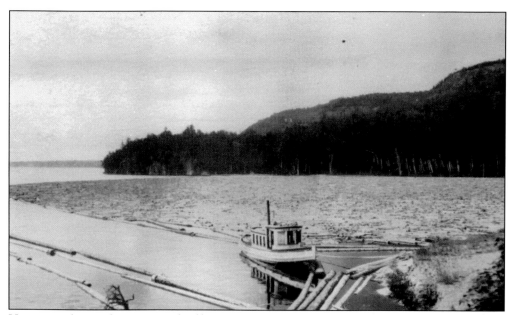

Here, a towboat is bringing a raft of logs into Ripogenus Dam at the foot of Chesuncook Lake. (Steve Rainsford collection.)

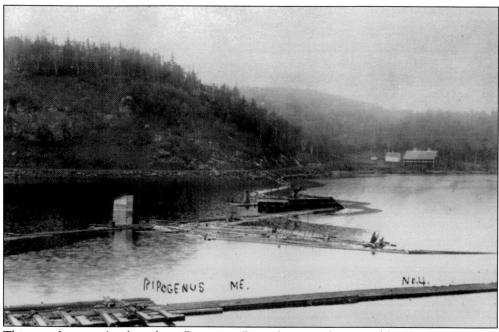

This is a photograph taken above Ripogenus Dam, showing a boom and headworks consisting of a capstan on the pier used to winch rafts of logs into place for sluicing. The boom strung across between the fender booms is known as a "gate boom." Logs will not pass through the dam until this boom is released.

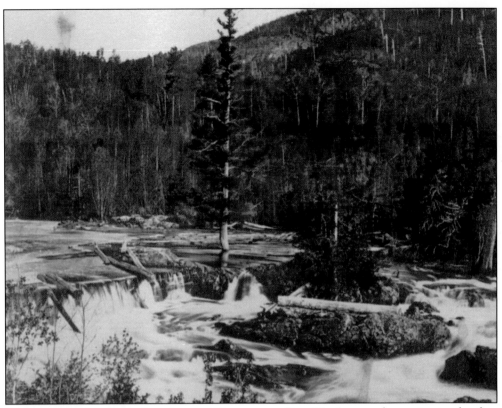

This photograph of the first dam at "Rappagenus Dry Way" was taken prior to the first timber structure.

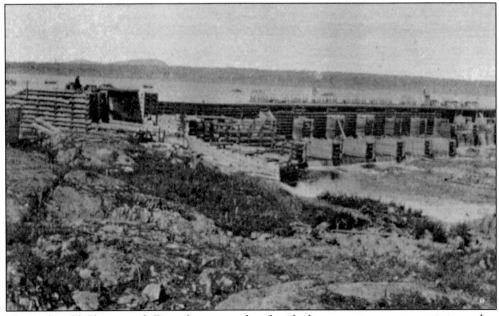

This is the old Chesuncook Dam that was replaced with the concrete structure existing today. It was obviously a very substantial piece of engineering. (From *In the Maine Woods*, 1911.)

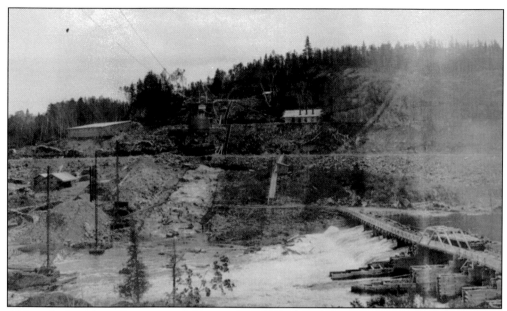

Although there have been several dams at Chesuncook Lake beginning c. 1834, the one that exists today was built in 1916. Before it, as the one shown here, was a timber crib dam built in 1903–1904 at a length of 1,500 feet. It contained six pair of deep 8-by-8-foot gates, three pair of shallow 8-by-12-foot gates, and a log sluice 25 feet wide. The dam controlled a head of about 20 feet.

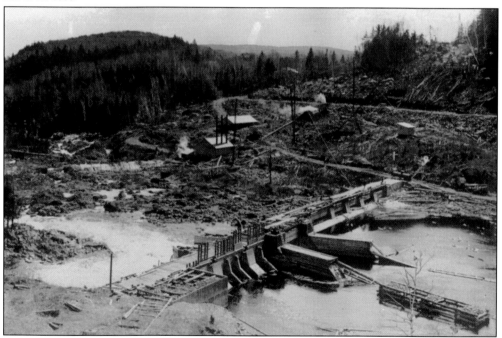

Here is an upriver view of the old dam during the new construction in 1916. The sluiceway is substantial in this dam, located in the middle, with structures both upstream and downstream to guide logs. Sheer booms are attached to the piers on the upriver side, also to guide the logs. (Steve Rainsford collection.)

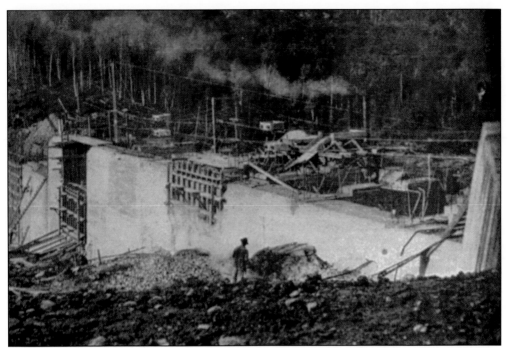

At this point, the concrete portion of the new dam is pretty well along. This photograph presents what a massive undertaking this was at the time. (From *In the Maine Woods*, 1916.)

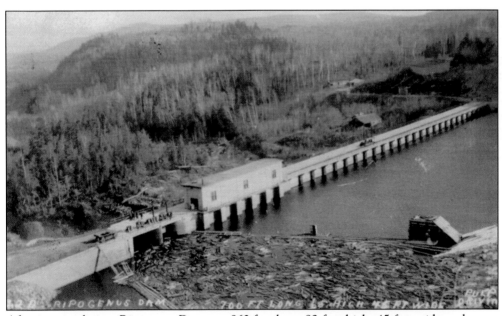

After its completion, Ripogenus Dam was 860 feet long, 92 feet high, 45 feet wide at the top, and 64 feet wide at the bottom. It was the third largest dam built in the United States, seventh largest in the world, and the largest privately owned hydropower dam. In this photograph, logs are being sluiced from the lake through the dam. (Steve Rainsford collection.)

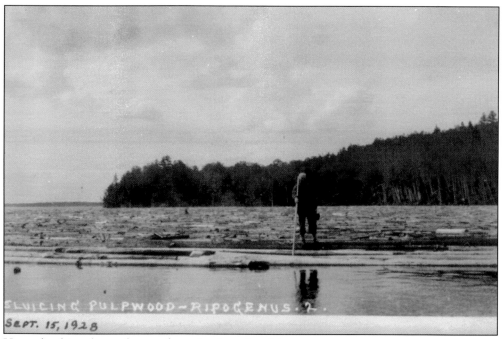

Here, the driver keeps the wood moving into the sluiceway.

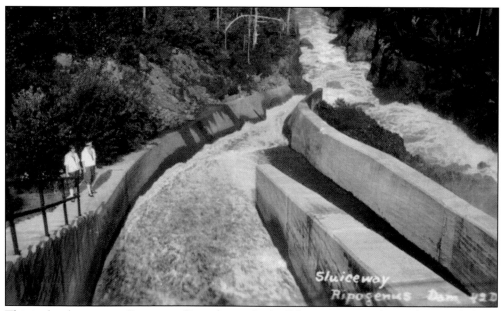

This is the sluiceway at Ripogenus Dam down which all logs were moved into the river below.

Here is another view of the sluiceway and the river below, known as Ripogenus Gorge. It is easily seen why a dam is important at this location and how wild the river below is when a large volume of water is released. The total descent in the gorge is 261 feet.

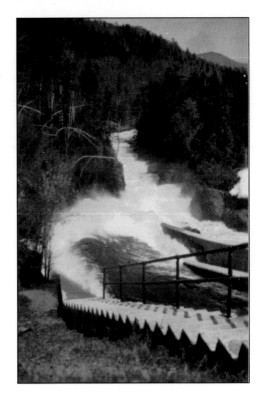

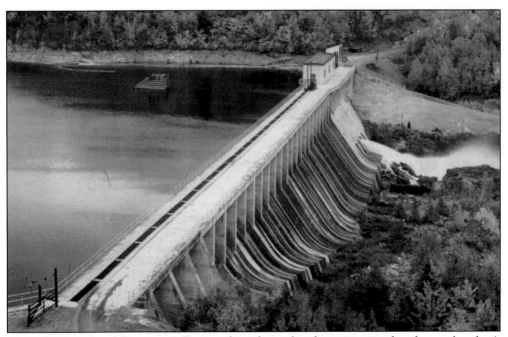

This photograph of Ripogenus Dam, taken from the downstream side, shows the dam's immensity. The sluice can be seen on the far side of the river.

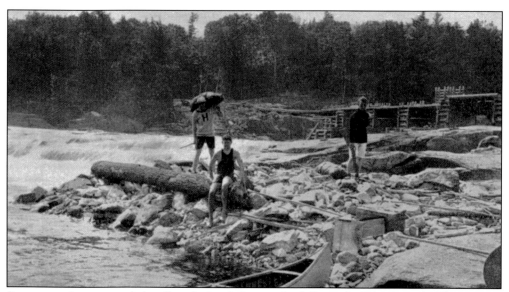

Summer students pause below Sourdnahunk Dam at the falls on the West Branch. This too was a substantial timber structure. Built in 1903, it was 233 feet long and contained eight gates and a 25-by-8-foot log sluice, as seen here.

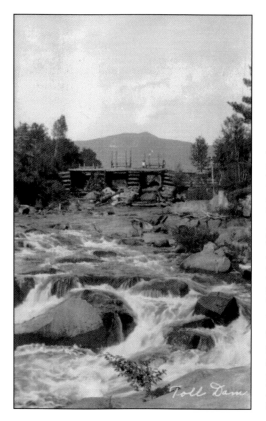

There were 30 toll dams chartered by the Maine legislature between 1834 and 1861, the first being in 1832. This one, probably the most famous, was rebuilt three times, beginning c. 1879. A fourth dam was built just below here in 1929. The original dam was built without iron, the logs assembled using juniper pins. The Sourdnahunk Dam and Improvement Company received a charter in 1878, authorizing them to "construct and maintain a dam or dams, with booms, side booms, sluices and other erections, and to make any other improvements necessary to facilitate the driving of the stream." It was given the right to collect toll for the passage of all logs and lumber through and over the improvements made by the corporation.

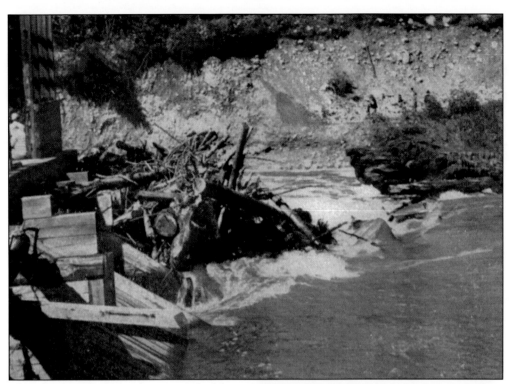

This photograph shows the west end of the toll dam on the morning of September 16, 1932, when a hurricane hit the region. It rained 12 inches in less than 24 hours, causing Sourdnahunk Stream to rise over 12 feet and wash away the toll dam. (From *In the Maine Woods*, 1933.)

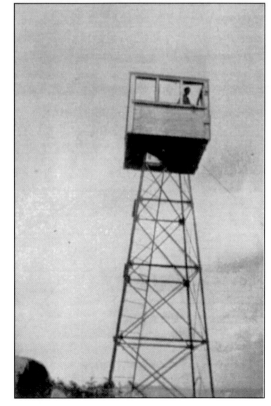

Here is one of the several fire towers located in Maine. Steel towers like this one were built beginning in 1914. By 1924, there were 64 towers throughout the state, 40 of which were made of steel. This one was built on Doubletop Mountain in the Sourdnahunk area. (From *In the Maine Woods*, 1934.)

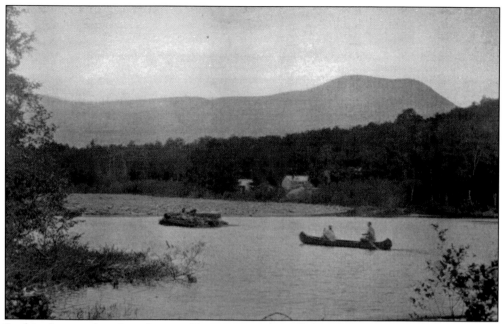
In this photograph, a large boom of logs waits at the toll dam for its next move. (From *In the Maine Woods*, 1930.)

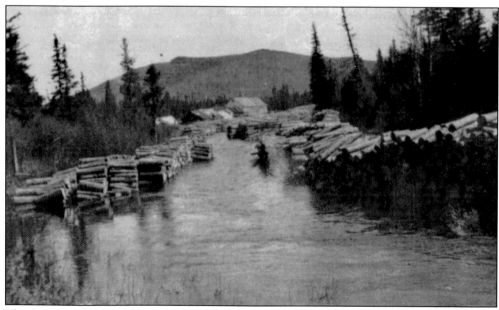
The Sourdnahunk log drive was one of the most significant in the state, both for long logs and pulpwood. Here, pulpwood is stacked along the shores of the stream. As the water rises from snowmelt, the drive is about to begin. (From the *Northern*, July 1922.)

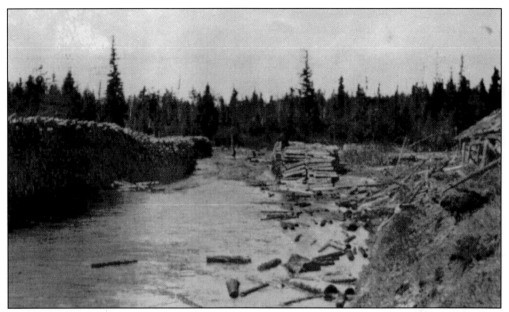

"Breaking the landings" was the term used to describe rolling the logs into the stream and prodding them into the current. Last winter's work in the woods is finally on its way. (From the *Northern*, July 1922.)

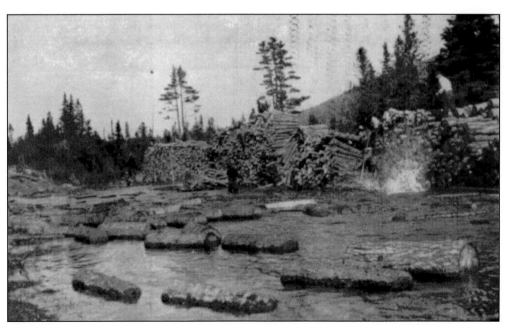

Getting wet is unavoidable in this type of work. Drivers would often spend all day in the cold water. (From the *Northern*, July 1922.)

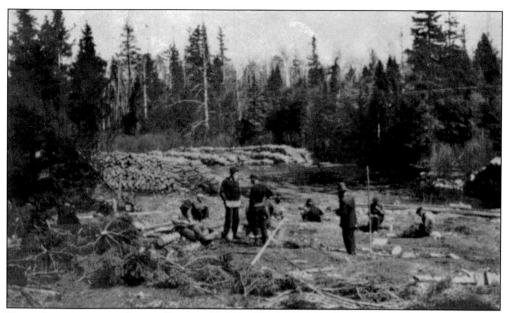
Here, the crew pauses for a well-earned lunch. (From the *Northern*, July 1922.)

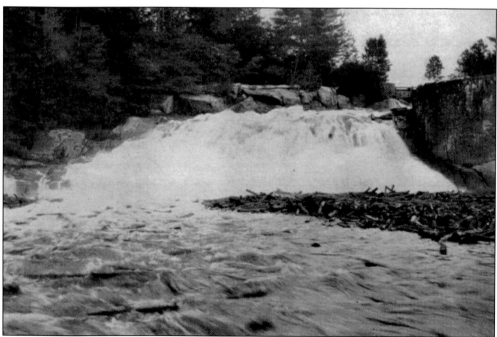
Sourdnahunk Stream was considered particularly difficult for driving, since in one-half mile there was a fall of 300 feet. A number of dams and other structures were built, and a few problem areas were cleared with dynamite. (From *In the Maine Woods*, 1930.)

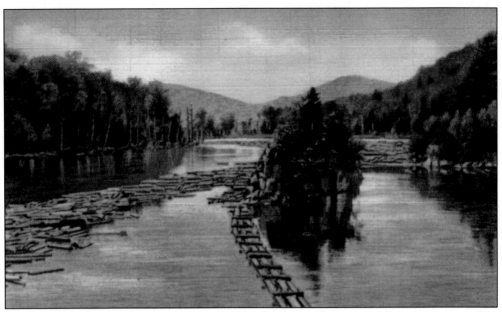
Finally out in the main current, considerably downriver, logs move along quite smoothly. Booms had to be maintained to guide logs away from islands and ledges.

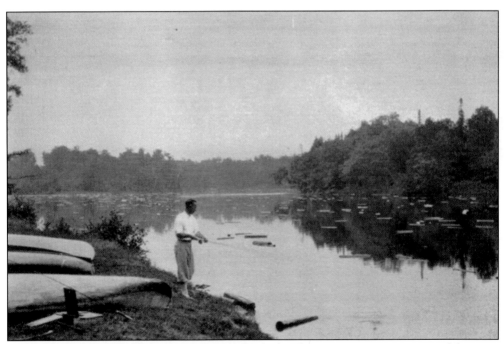
While the river is full of logs, an angler tries his luck. These were competing uses of the river, since some of the best fishing occurs early in the season when the drive is on.

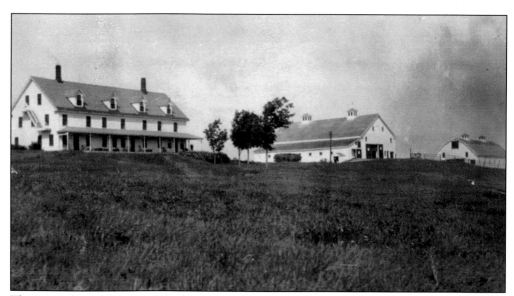

This is another of the Great Northern Paper Company's farms, of which there were several. The Grant Farm was located near Ragged Lake, about halfway between Lily Bay on Moosehead Lake and Ripogenus Dam on the Penobscot River. The farm began in 1841 and was purchased by the Great Northern Paper Company in 1901. In 1910, the company rebuilt the house as shown here. It was the main source of supply for operations to the north. The farm was closed in 1947, but the telephone operators stayed on until 1960, maintaining contact with the various woods operations and the main offices.

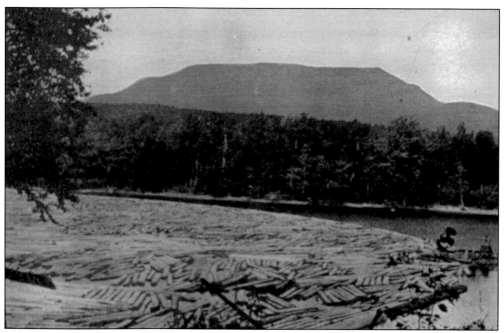

Below Sourdnahunk Stream is Abol Falls, on the main part of the Penobscot River. Note the raft and capstan, on the right, used to winch the booms on small areas where tugboats could not be used.

This is a photograph of the Grand Falls of the East Branch of the Penobscot River. It is obviously a troublesome spot. (From *In the Maine Woods*, 1926.)

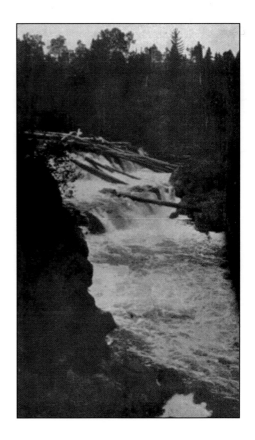

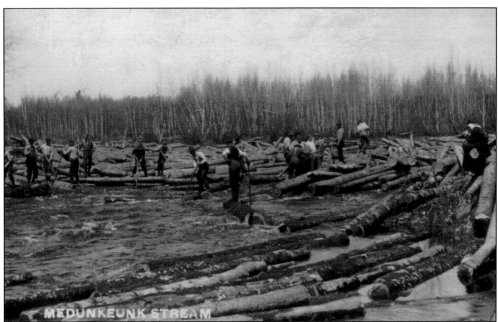

The crew tries to clear a jam and keep the wood moving. This stream is a tributary to the Penobscot River at Lincoln.

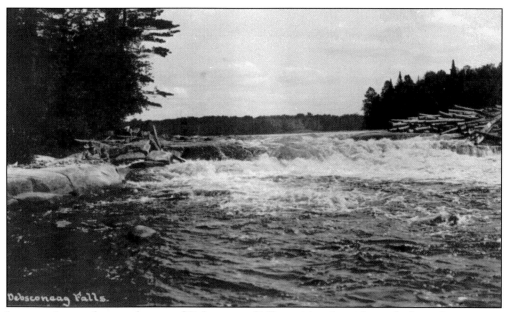

Logs are jammed up at the top of Debsconeag Falls, waiting for either a freshet of water or a crew of strong men to get them moving again.

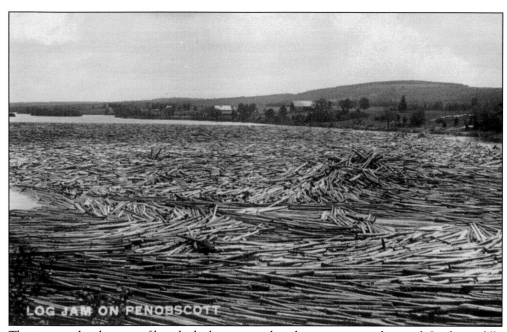

This is a good indication of how bad a logjam can be when it gets out of control. In the middle of the photograph, the logs are pushed up in a jumbled pile.

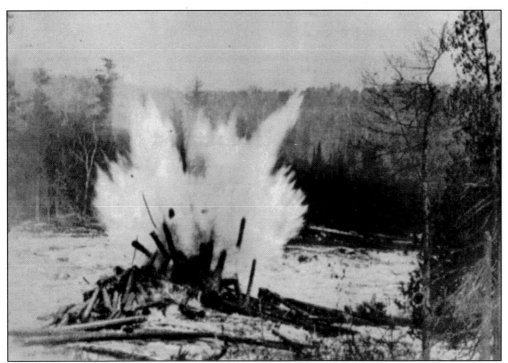

When all else fails or when a jam becomes massive, dynamite is used to break away the key logs responsible for it all. This c. 1908 picture was taken on the Penobscot River at Debsconeag. (From the *Northern*, July 1928.)

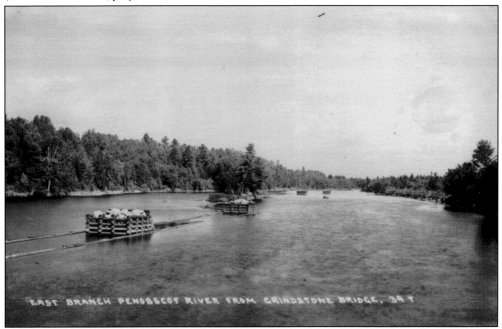

On the East Branch of the Penobscot River, these piers and booms help keep the wood in the main current and away from islands, as shown here, and other obstructions that could easily cause a jam.

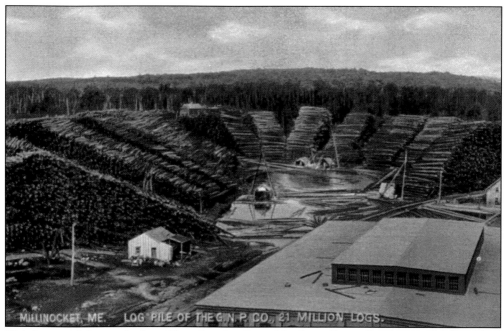

This is one of the stockpiles of logs for the Great Northern Paper Company in Millinocket. These are all long logs, most of them probably driven down the Penobscot River during the past year or so.

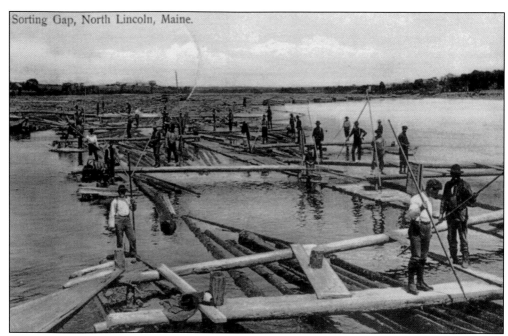

As logs near their destination, they were sorted according to ownership. Note the size and complexity of this operation. This is one on the Penobscot River. The ones on other major Maine rivers were similar in structure and operation.

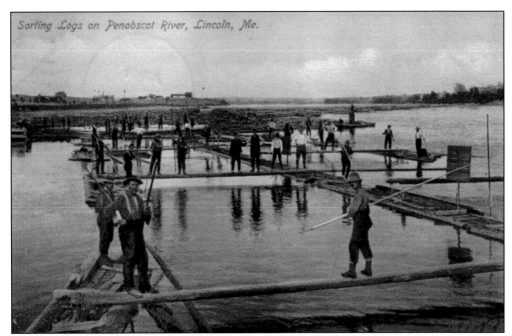

This is the same location but a different view from the previous photograph. As logs came floating through the sorting gap, each "checker" was responsible for certain marks on the logs indicating their ownership. When he saw one, he would give it a vigorous push toward shore, where a rafting crew would fasten it to other logs similarly marked. Every so often, the gap would be closed and the crew on shore would assemble their rafts of logs, which would be winched or towed down the river to their destinations.

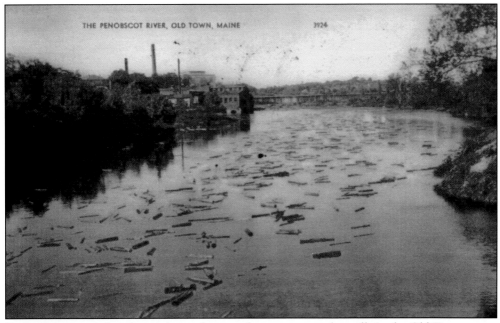

During later years, four-foot pulpwood moves downstream to the mills in the Old Town area.

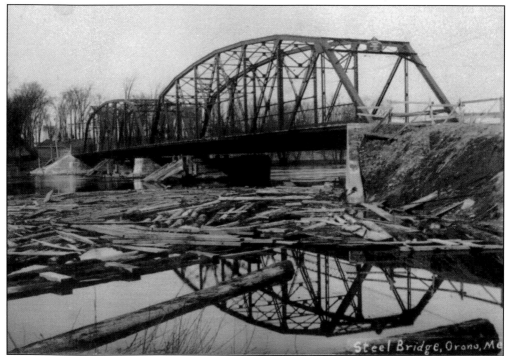

A tributary to the Penobscot River at Orono is the Stillwater River. Much timber was cut from here northwestward toward Milo and Brownville, driven down tributary stream to this river, and eventually into the Penobscot River.

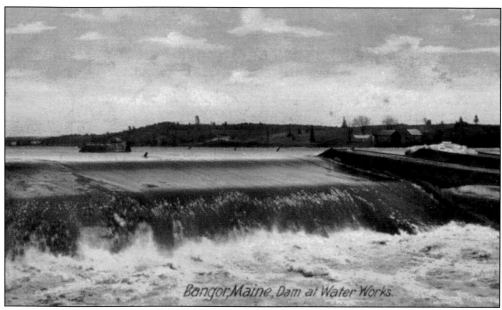

At the famous salmon pool in Bangor, at the head of tide, is the Bangor Dam. Piers upriver can be seen in this picture, along with the sluiceway located in the middle of the dam to the right.

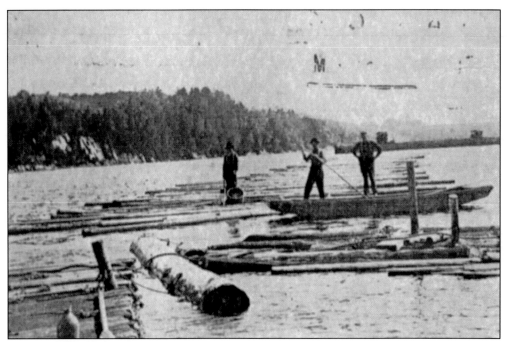

Here is another sorting area located in Bangor.

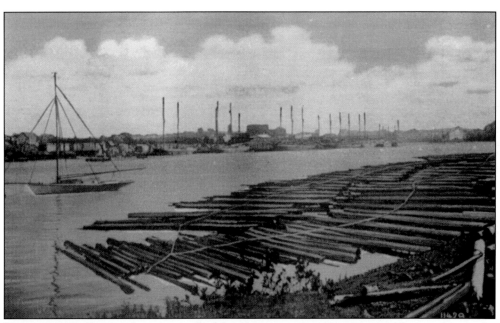

Upon reaching Bangor, logs were rafted by owner—some to be processed here, others to be moved farther downriver, and still more to be loaded aboard ship for transportation elsewhere. The masts of several schooners can be seen on the opposite shore.

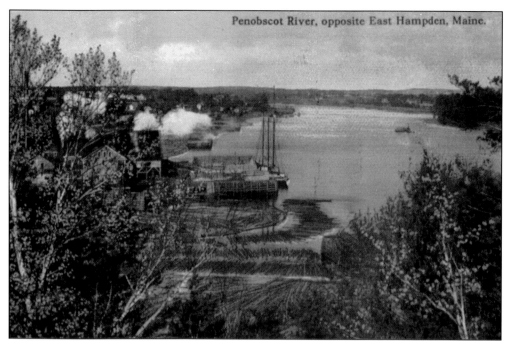

The first sawmill in Bangor was built in 1771. This is possibly the Hathorn Mill, one of the many mills in the Bangor-Brewer area. In 1836, it was written that "there are now in operation, night and day, within a few miles of Bangor, primarily with the limits of Orono, more than 200 sawmills for boards manufacturing more than 1,500,000 feet of boards daily." By 1840, there were 42 sawmills in Bangor alone.

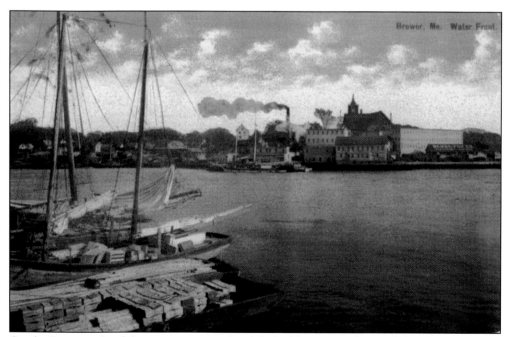

On the Brewer side of the river are a couple of docked boats. Lumber and shingles are stacked here waiting to be loaded.

Bangor was called the beginning—the first town devoted entirely to manufacturing and shipping lumber and entertaining loggers. It is situated at the head of tidewater and therefore the end of the drive, or the downstream terminus of moving logs. In 1860, Bangor was shipping 250 million board feet of long lumber a year. That year, more than 3,000 ships arrived and anchored.

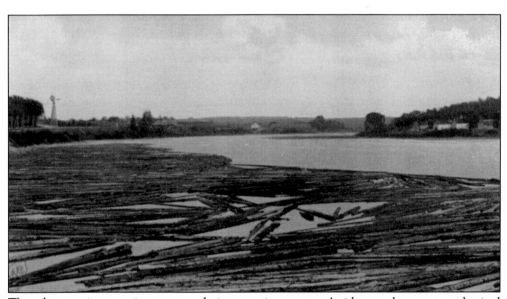

These logs await separation to go to their respective owners. A tidewater boom was authorized here in 1856.

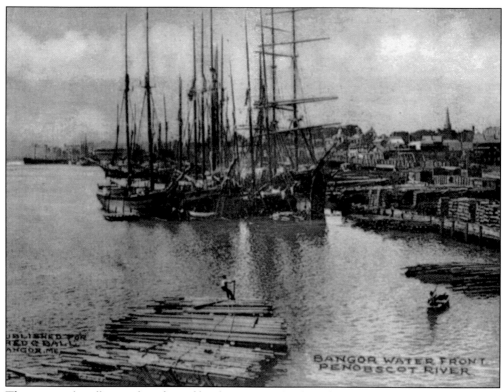
This crew is bundling up bunches of lumber prior to loading them aboard ship.

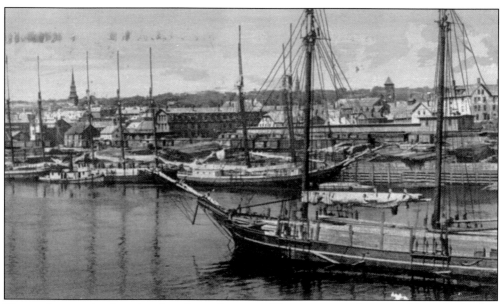
These photographs show just how busy the port of Bangor was at this time. Note the lumber stacked on deck of the ship in the foreground. In 1860, ships lying at anchor were so thick that a person could walk across the river on their decks by jumping from ship to ship. Ships came here from all over the world.

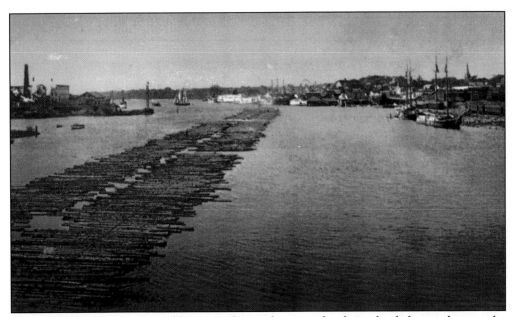

These logs have been separated by ownership and await either being loaded onto ships or else being towed downriver to the appropriate mill. It was reported that in 1860, some 3,376 vessels arrived in Bangor to take on lumber. On July 14 of that year, there were 60 vessels anchored below the bridge within two hours. In the 200 to 250 sailing days in a year, when the river was free of ice, average daily arrivals were 12 to 15.

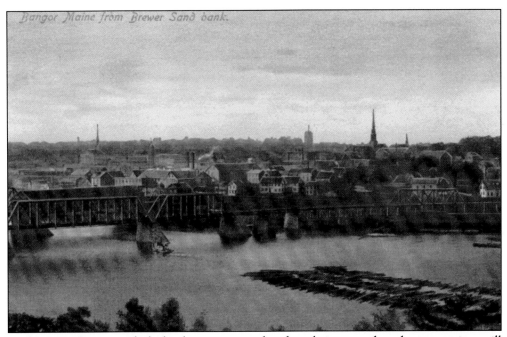

In this view, logs are rafted after being separated and are being towed to the appropriate mill for processing.

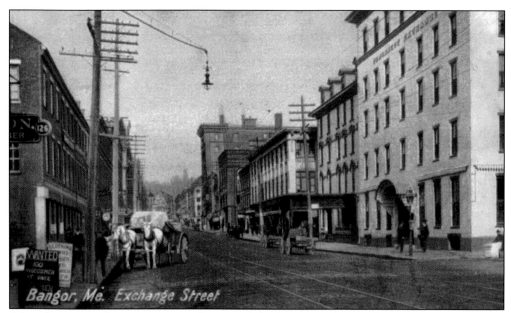

After the spring drive was over and many of the loggers and river drivers found themselves in Bangor, Exchange Street was often where they ended up. This area was widely known for its hotels, rooming houses, taverns, and brothels, not to mention logging supply houses. Most loggers left Bangor penniless, having spent their winter paycheck, and headed back north to work in the woods another season. This area was known as Hell's Half Acre.

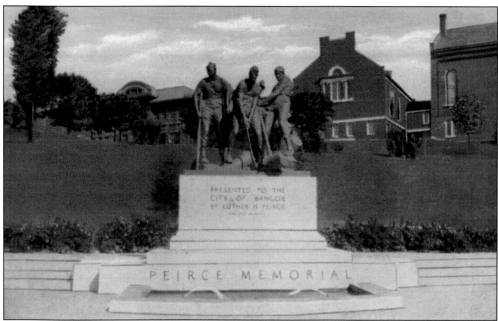

As a tribute to river drivers, this sculpture was placed in a park next to the Bangor Public Library. It is titled *The Last Drive* and was commissioned by the Peirce family as a memorial to Luther H. Peirce. The sculpture was created by Brewer native Charles Eugene Tefft, who made a number of sculptures commemorating American notables. The Peirce family was associated with the lumbering industry.

Five

AT THE MILLS

The first sawmill in America is said to have been located "near York" in 1623, or thereabouts, although the record is not well authenticated. The second one was located at South Berwick in 1630–1631. This photograph was taken at or near that site.

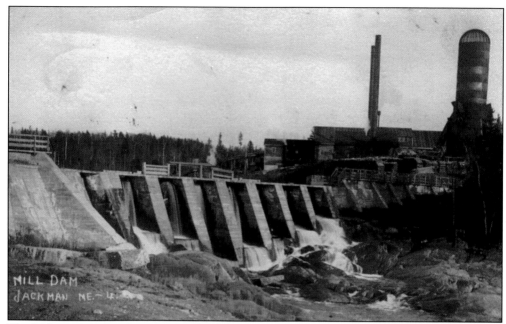

The Jackman Lumber Company mill was located in Moose River Township on Heald Stream. It opened in 1914 and employed, at its height, more than 600 men in the woods and at the mill. The mill could saw 25 to 30 million feet of lumber per year. It burned in 1926 and all that remains are part of its foundation, remains of the dam, and parts of the railroad bed used to transport logs from the woods operations.

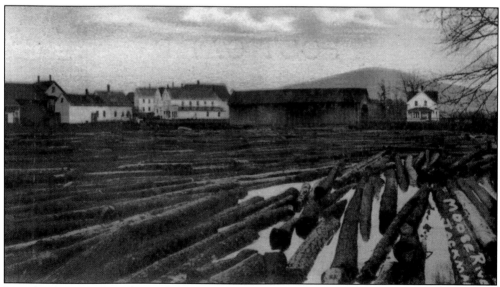

Long log drives such as this ended in this area in 1927. Pulpwood drives continued until 1976. Here, Moose River is "bank full" of logs being driven downstream to the mill, most likely to the Kellogg Lumber Company Mill, which located downriver at Long Pond c. 1907 and operated until 1926. The Moose River Dam Company was established in 1848.

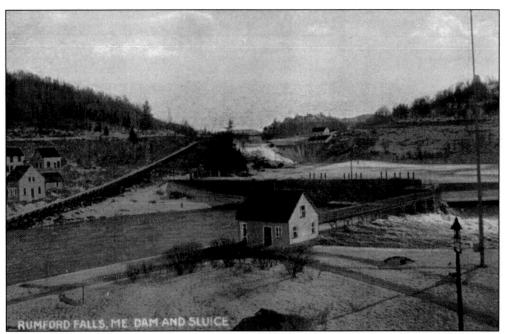

The Rumford area has long been a major location for pulp and paper mills. Located on the Androscoggin River, it is served by a number of tributaries in both Maine and New Hampshire, drawing from a large area. The falls shown here presented a major obstacle to the movement of logs, so a substantial sluice was constructed to bypass the bad river conditions.

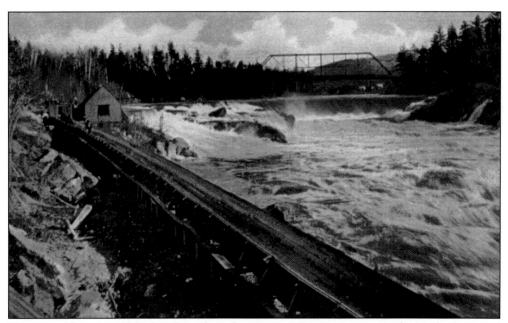

Here is another view of the log sluice from downstream. In some areas, canals were built around difficult places. Although several were enacted by the legislature, few were built. Sebago along the Presumpscot, Stillwater, and the Telos Canal were the most noteworthy.

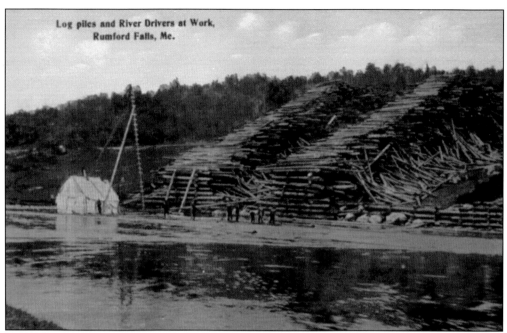

Here, drivers work to handle logs coming down the river. A substantial inventory is shown in this picture. The first boom on the Androscoggin was built in 1789. Side booms were authorized in 1805 and 1812.

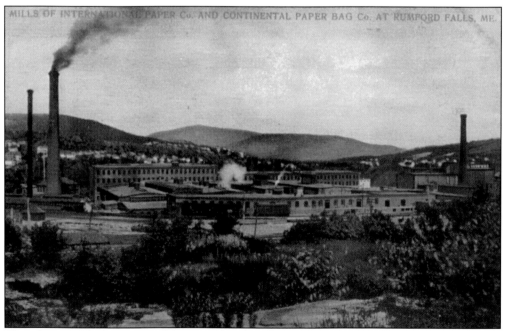

This photograph shows two of the several mills located at Rumford, both pulp and paper mills. It was estimated that there were 23 major freshets on the Androscoggin River from 1723 to 1873. Mills were swept away in 1814, 1819, 1820, 1832, and 1839.

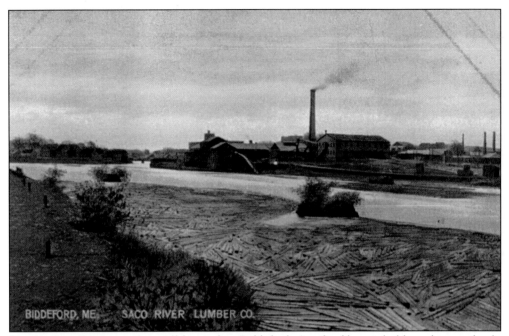

On the Saco River was this mill located in Biddeford. A raft of logs is held on the near bank, anchored to the piers, while another boom is anchored on the far shore, ready to be moved into the mill yard.

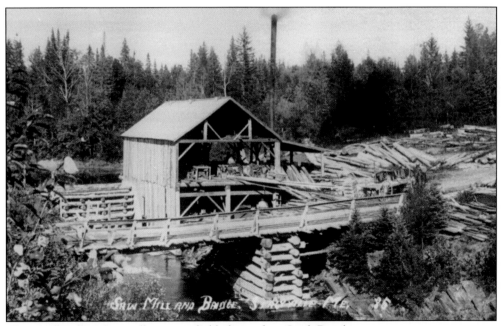

This small mill in Stacyville was probably located on Swift Brook.

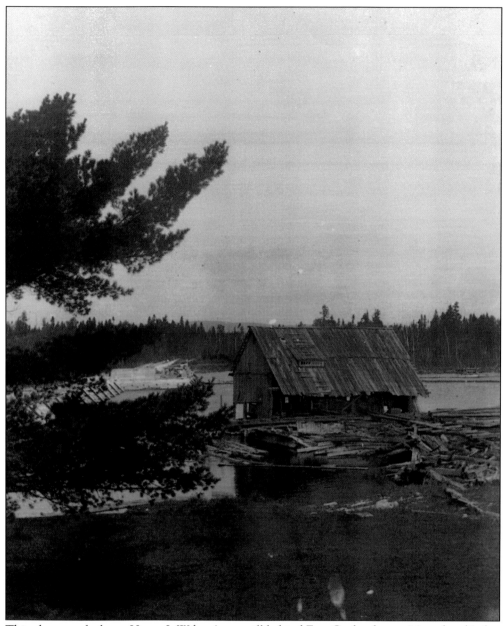

This photograph shows Henry I. Wilson's sawmill behind East Outlet dam at Moosehead Lake. The photograph was taken soon after 1865. This was typical of small sawmill operations about this time.

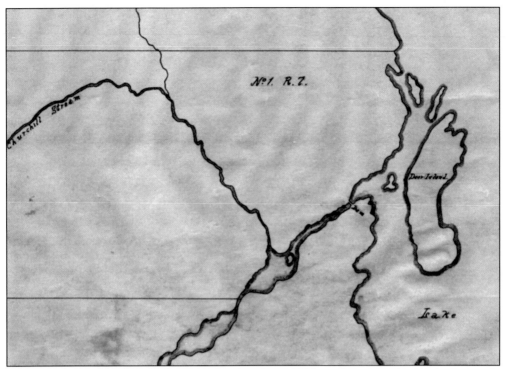

The East Outlet dam was in place at least as early as 1847, as shown on this copy of an early survey plan by John Pierce, Silas Hamblet, and Horatio Coss. (Copied from Somerset County Registry of Deeds, book 1, page 13.)

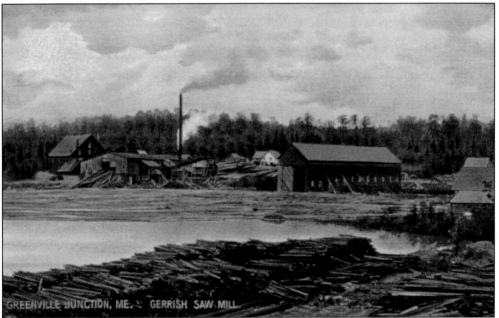

The Gerrish sawmill was also located on Moosehead Lake at Greenville Junction. A large inventory of logs sits in a boom in the lake, where it is protected from attacks of insects, disease, and fire.

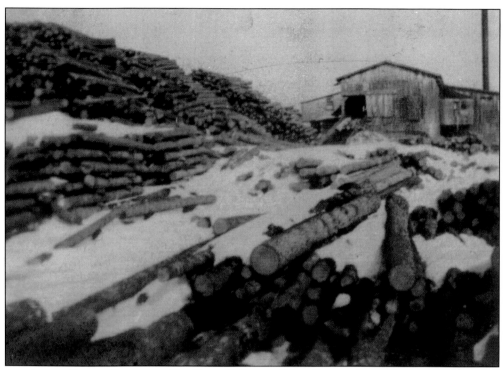
Another small sawmill was owned by Chase & Sons at Sebec Station. (Steve Rainsford collection.)

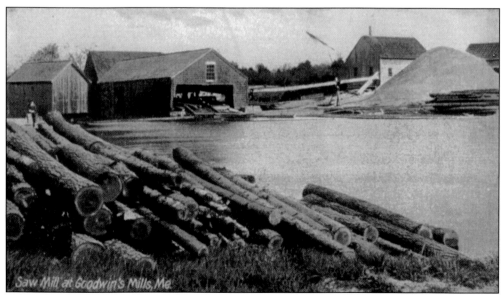
Pine logs await the saw at this mill between Saco and Sanford. The entrance to the mill, as logs are pulled from the holding pond, can be seen here.

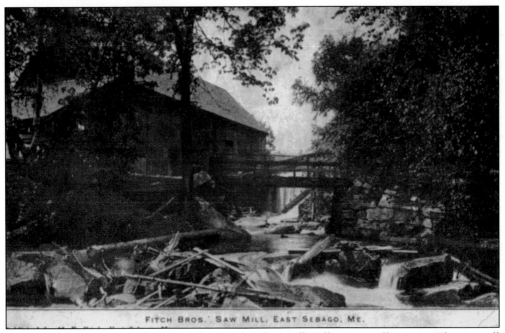

The Fitch Brothers sawmill is a good example of a small mill on a small stream. The sawmill was built in 1866 on the original site of the gristmill built by William Fitch, who was in Sebago, c. 1790.

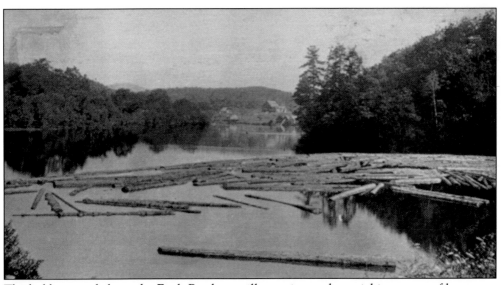

The holding pond above the Fitch Brothers mill contains a substantial inventory of logs.

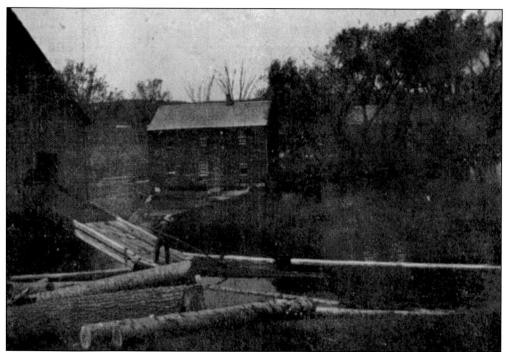

This mill was located in Strong on the Sandy River or a tributary thereto. Here, a worker guides logs to the bull chain that will transport them to the saw carriage.

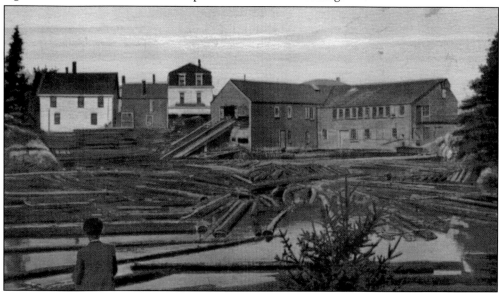

On tidewater, the movement of the tide serves to operate a mill such as this one in East Boothbay. The business end of the mill is shown in this photograph, where the logs enter from the holding area. With such mills, water was usually controlled by two dams. One was in the usual place behind the wheel with a sluiceway and gate to deliver and release the water, the other at the tidal inlet, where seawater flowed in a high tide and was trapped by closing the gate through which it entered. The big disadvantage was that mill schedules had to be coordinated with tidal movements.

Now just a little-used path through the woods, this lane was once a major route of travel for loggers and river drivers. The Maine Woods are littered with paths and trails such as this, most of them now overgrown or obliterated by more recent logging activities from the "second wave" or other woods operations.

BIBLIOGRAPHY

Bangor & Aroostook Railroad Company. *In the Maine Woods*. Various years.
Barnes, Diane and Jack. *The Sebago Lake Area*. Charleston, S.C.: Arcadia Publishing, 1996.
Blanchard, Dorothy A. *Old Sebec Lake*. Charleston, S.C.: Arcadia Publishing, 1997.
Coolidge, Philip T. *History of the Maine Woods*. Bangor, Maine: Furbush-Roberts Printing Company Inc., 1963.
Down East Magazine. *Maine Lakes Steamboat Album*. Camden, Maine: Down East Enterprise Inc., 1976.
Hempstead, Alfred Geer. *The Penobscot Boom and the Development of the West Branch of the Penobscot River for Log Driving*. University of Maine Studies. Second Series, No. 18. Vol. XXXIII, No. 11, 1931.
Hilton, C. Max. *Rough Pulpwood Operating in Northwestern Maine, 1935–1940*. University of Maine Studies. Second Series, No. 57. Vol. XLV, No. 1, 1942.
Holbrook, Stewart H. *Yankee Loggers*. New York: International Paper Company, 1961.
Ives, Edward D. *Argyle Boom*. Orono, Maine: University Press, 1977.
Jackman Bicentennial Book Committee. *History of the Moose River Valley*. K.J. Printing.
Jackson, Herbert G. Jr. *Boat Rides, Blueberries and Band Concerts. Steamboat Days on Sebec Lake.* In *Maine Lakes Steamboat Album*. Camden, Maine: Down East Enterprise Inc., 1976.
MacDougall, Walter M. *Moosehead Lake Steamboats*. In *Maine Lakes Steamboat Album*. Camden, Maine: Down East Enterprise Inc., 1976.
The *Northern*. Social Service Division, Great Northern Paper Company Spruce Wood Department, July 1922 and July 1928.
Pike, Robert E. *Tall Trees, Tough Men*. New York: W.W. Norton & Company Inc., 1967.
Rivard, Paul E. *Maine Sawmills: A History*. Augusta, Maine: Maine State Museum, 1990.
Simmons, Fred C. *Northeastern Loggers' Handbook*. U.S.D.A. Handbook No. 6. Washington D.C.: USGPO, 1951.
Smith, David C. *A History of Lumbering in Maine, 1861–1960*. University of Maine Studies, No. 93. Orono, Maine: University of Maine Press, 1972.
Sorden, L.C. and Jacque Vallier. *Lumberjack Lingo*. Madison, Wisconsin: North Word Inc., 1986.
Wood, Richard G. *A History of Lumbering in Maine, 1820–1861*. University of Maine Studies. Second Series, No. 33. Vol. XLIII, No. 15, 1961.